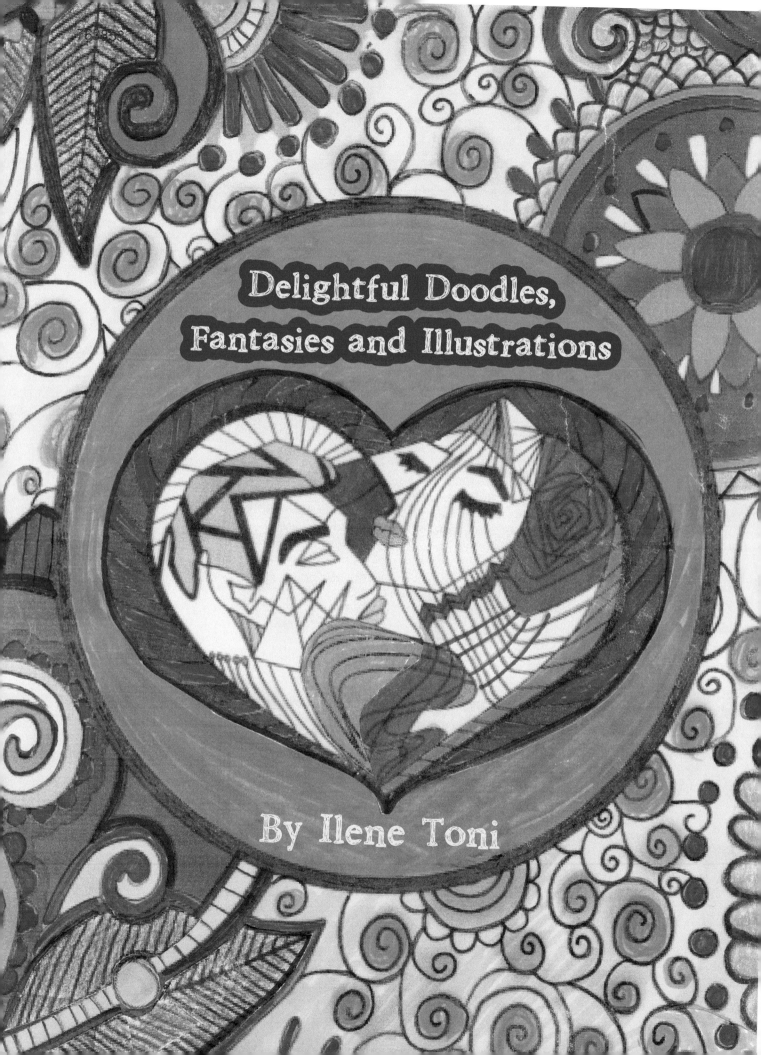

Delightful Doodles, Fantasies and Illustrations

By Ilene Toni

To order additional copies of this book, contact:
Xlibris
844-714-8691
www.Xlibris.com
Orders@Xlibris.com

ISBN: Softcover 978-1-6641-4605-1
 EBook 978-1-6641-4604-4

Print information available on the last page

Rev. date: 12/09/2020

My History

My journey to become an artist began when I was five. My mother would take me walking in the woods. I would imagine faces in the bark of the trees. At six, she bought me a chalk board easel. At the top of the easel were pictures on a scroll. At the bottom of the easel colored chalk that I used to draw with. One day I drew a house and trees that looked like the one on the scroll. I called my mother in to see and I exclaimed "I must be an artist?"

I was seven and in my third grade class. My teacher Mrs. Castle handed out a picture for each child to draw from. I was handed the cover of a Times magazine, with a photograph of astronaut John Glenn. As I drew his helmet I watched the lines appear on the paper. I thought to myself, what type of drawing is this called? It must be called a line drawing and at that moment I knew I was an artist.

My mother has always been supportive of my art work. The one thing that she did not agree on was my using up all her scrap paper to doodle on. I saved those doodles all these years. Each one of those doodles helped me to envision the theme of each drawing. I have designed three categories of drawings, Doodle are fun and engaging, Fantasies take you on a magical journey, Illustrations are of major cities around the world.

Line drawing is my favorite way to express my creativity and is the style used in each picture. I created each drawing with a pencil and a ruler. Since I do not know how to draw with the computer, I used tracing paper to transfer the finalized drawings. Then I used sharpies in all sizes to complete the look of each picture.

I would like to thank my Grandfather for my creativity. I would also like to thank my son, he was the one who inspired me, and he has told me he is proud of me.

I am glad I have gotten to work with the team of Xlibris, it has been a privilege to have created this book under their guidance.

I want to thank Kara Cardeno, her spirit and excitement for my book helped skyrocket my creativity. Also her determination has helped to get Delightful Doodles, Fantasies and Illustrations, published.

I would like to thank Iris Johannsen, who has been the glue between all the collaborators; with her patience has guided me through all phases of the book.

I would like to thank and honor diverse cultures. I designed pictures of major cities around the word. I include North America, South America, Africa, China and Europe. I hope at least one picture relates to your families heritage and culture.

Sincerely,
Ilene Toni

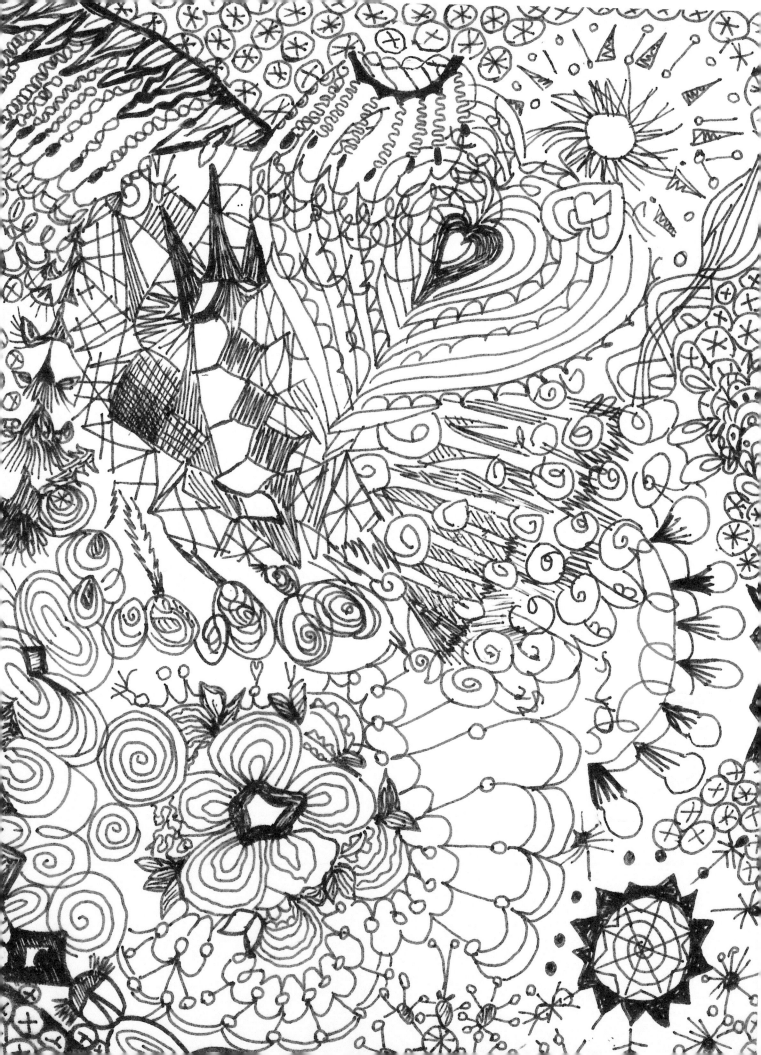

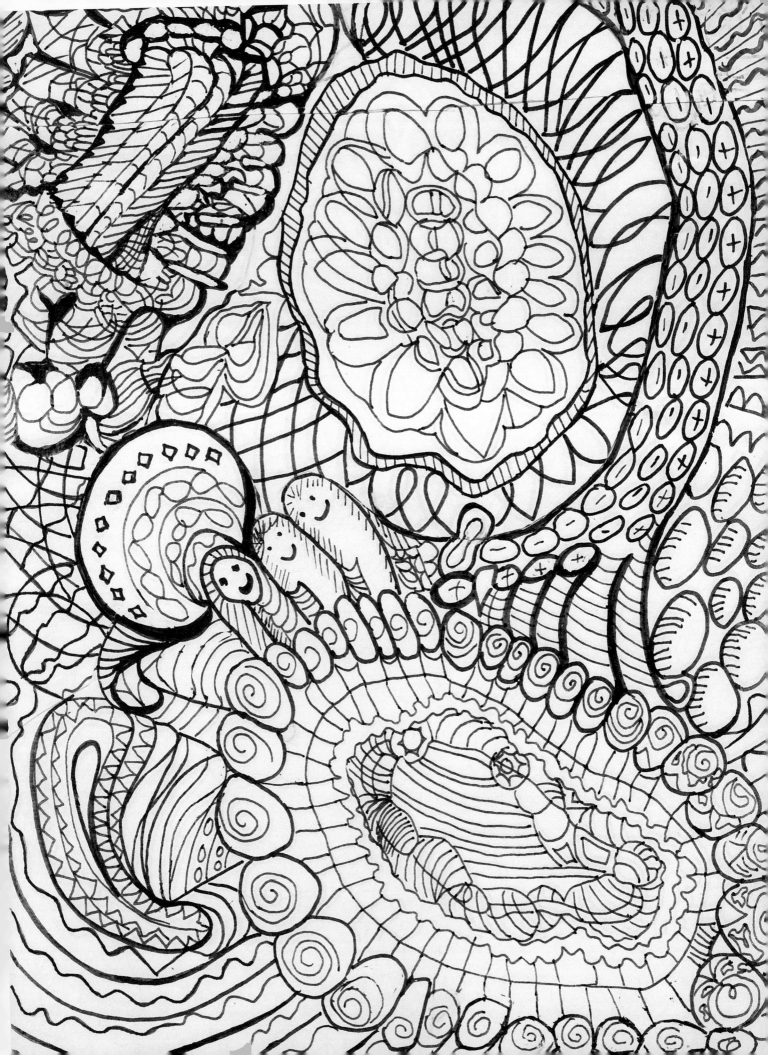

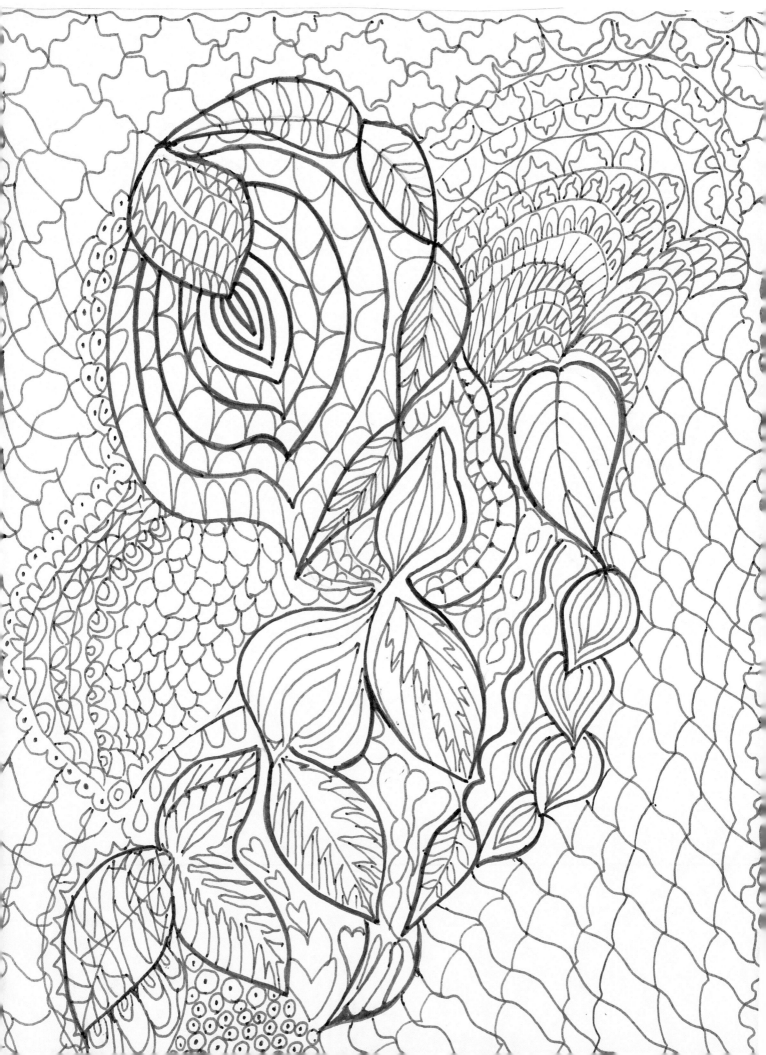

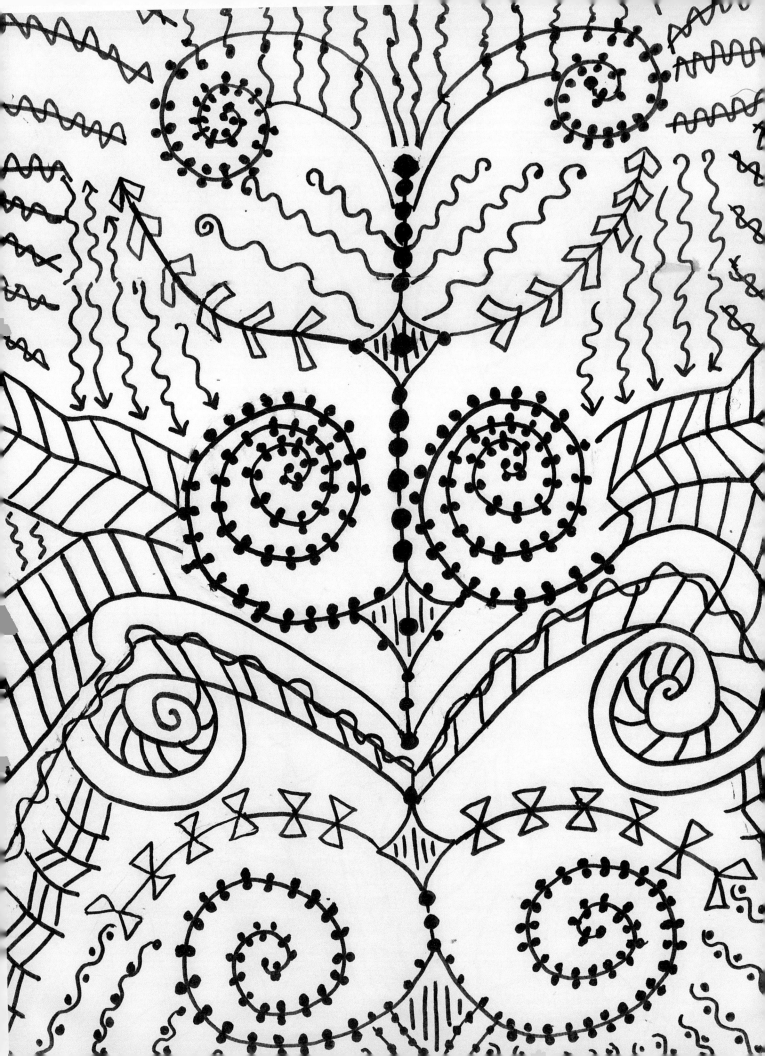

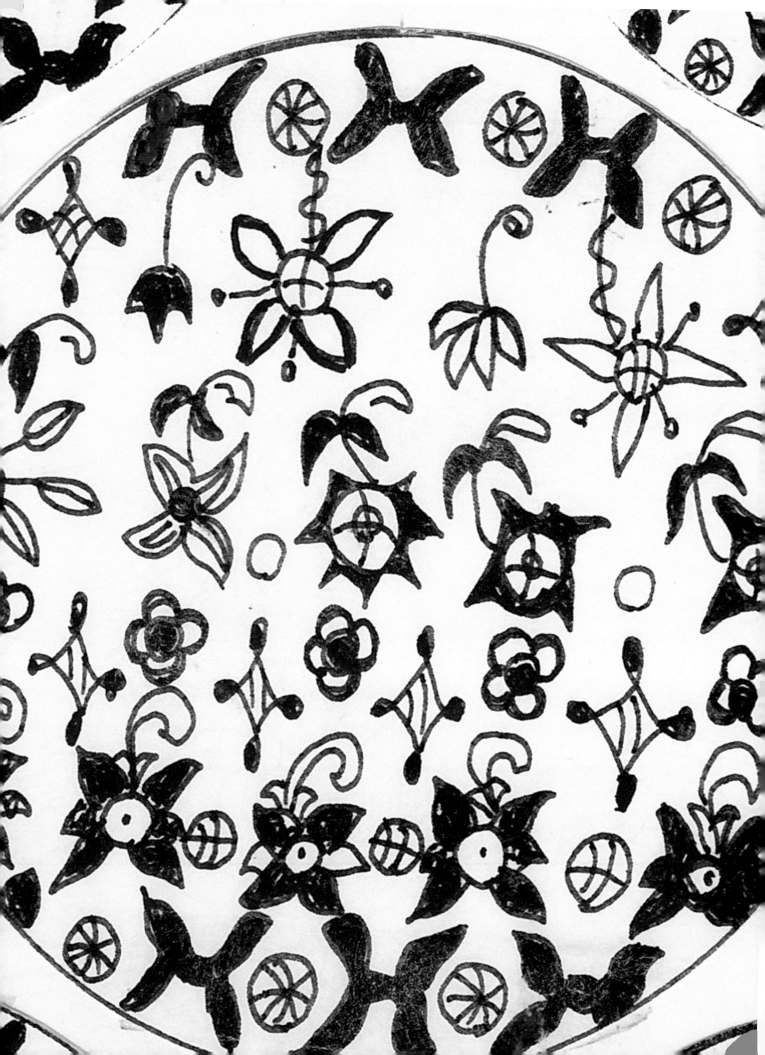

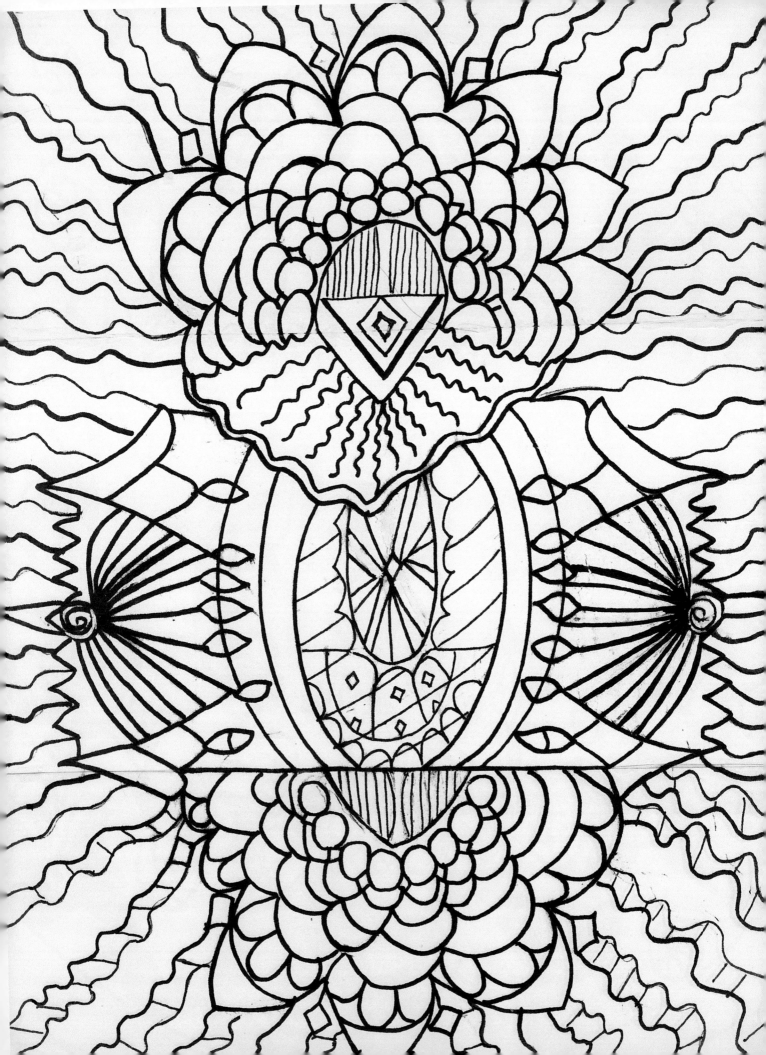

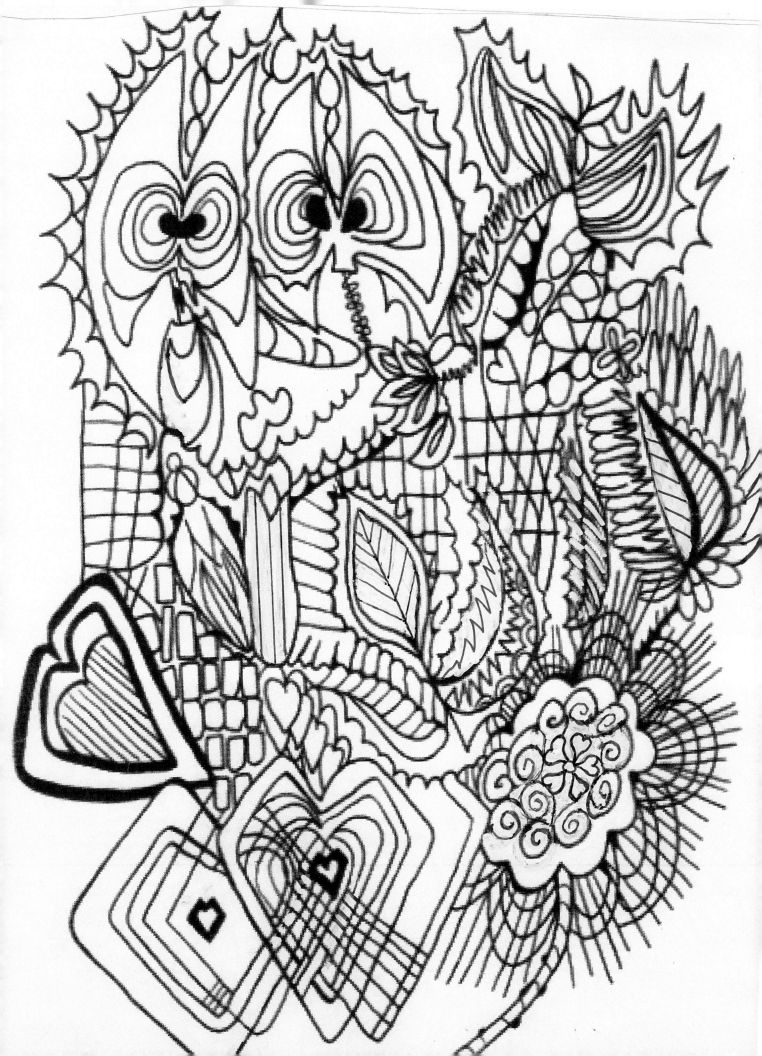

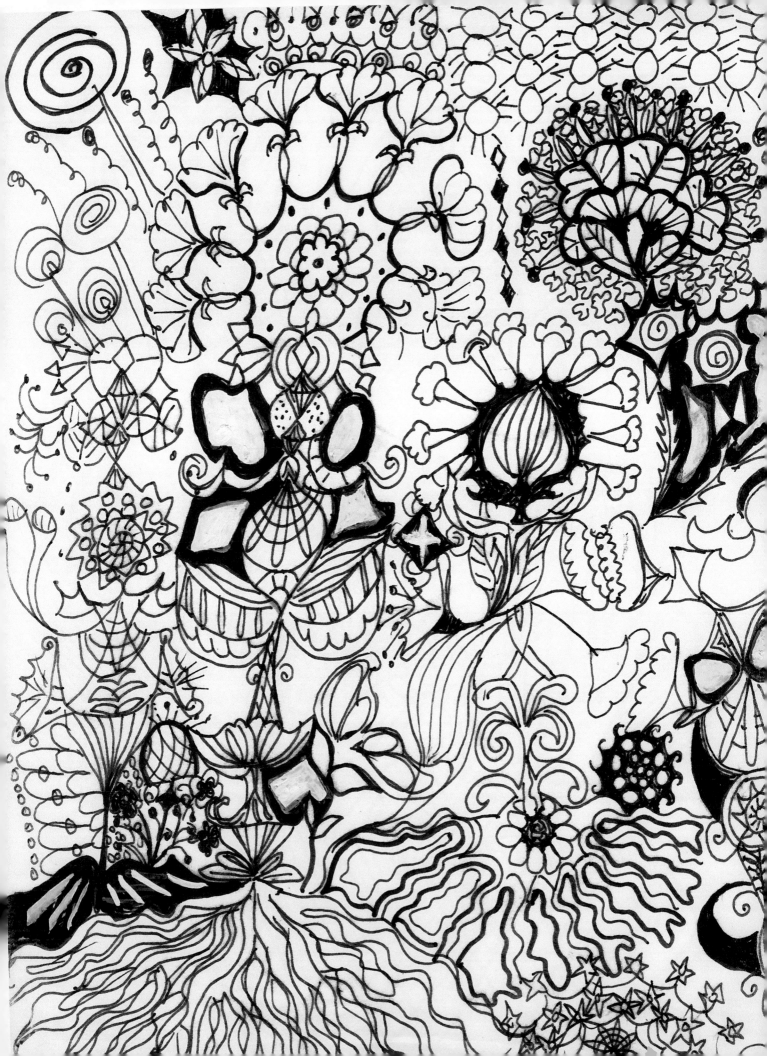

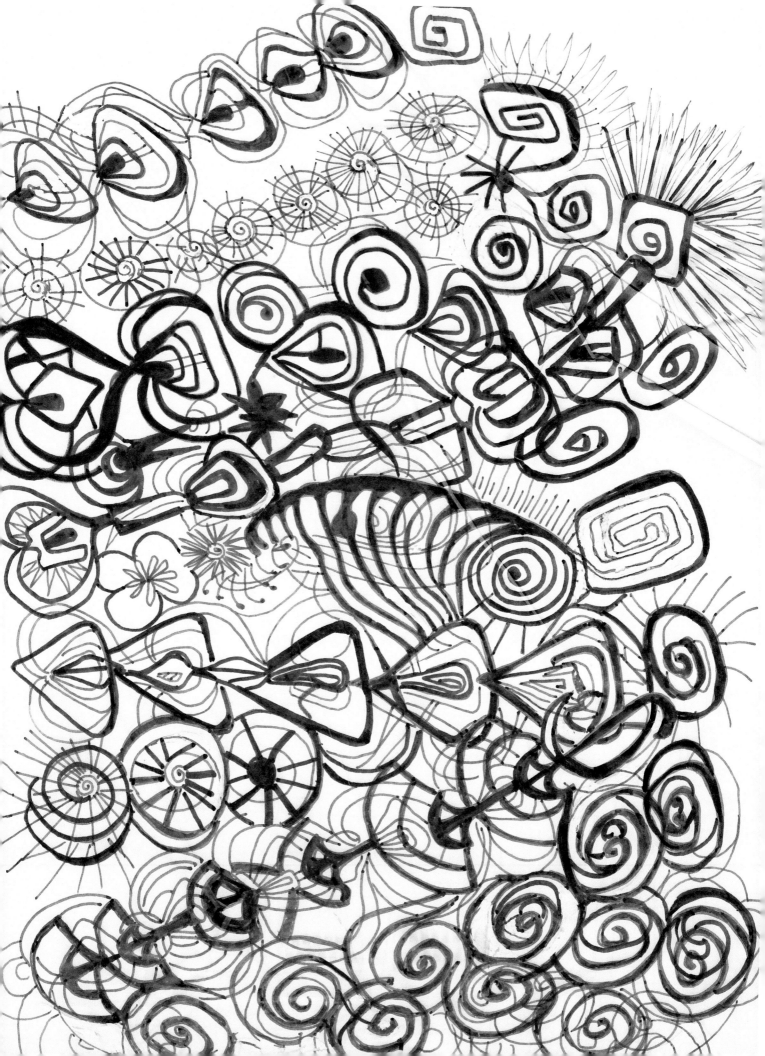

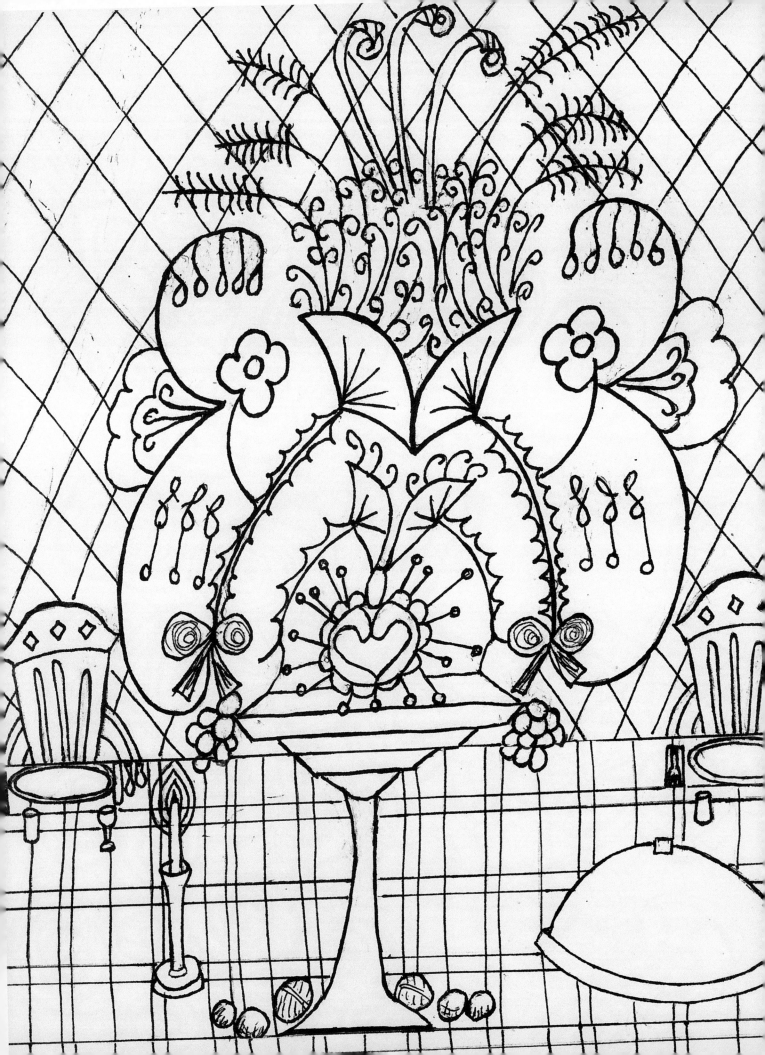

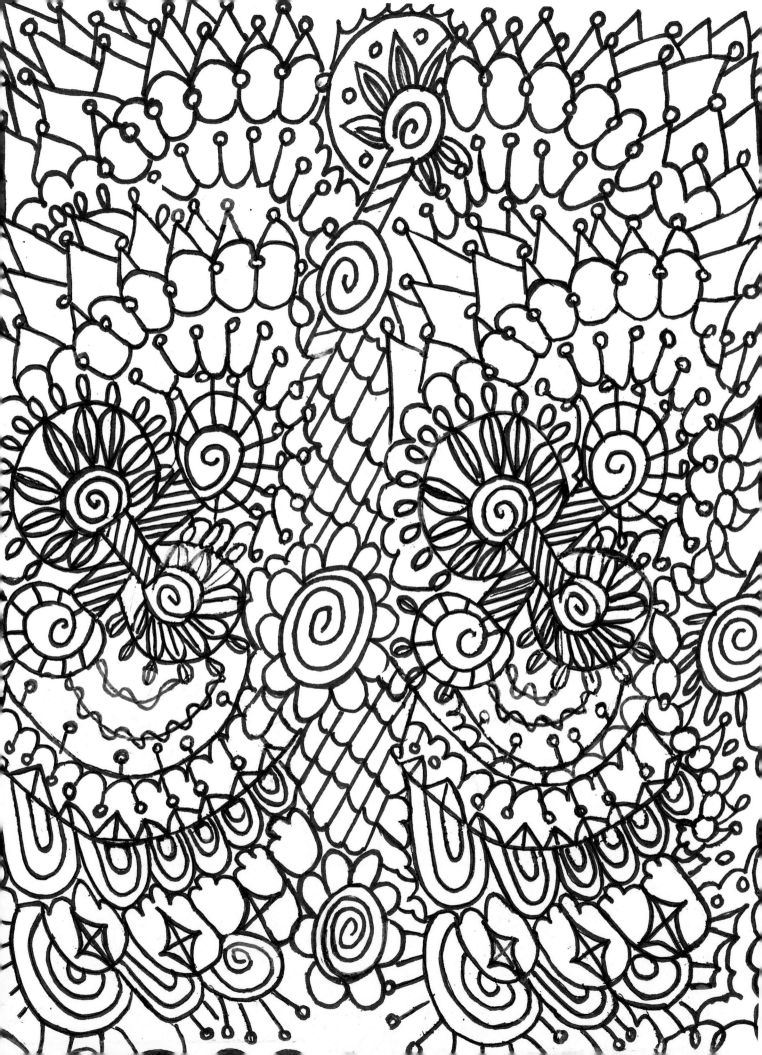

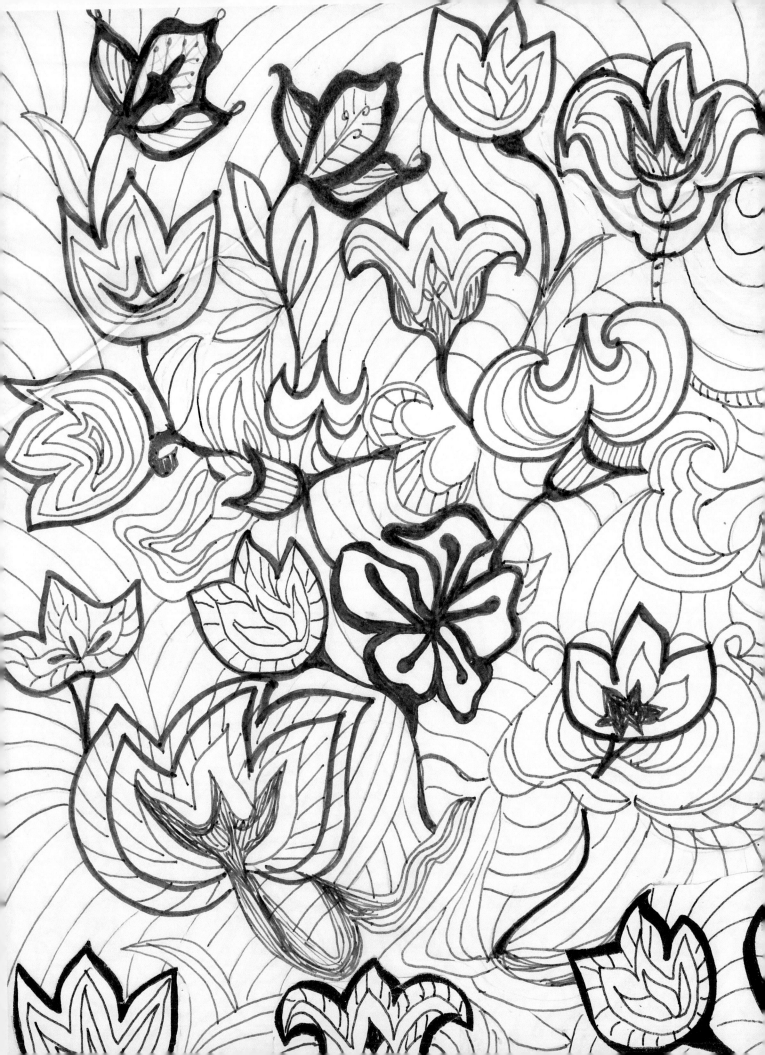

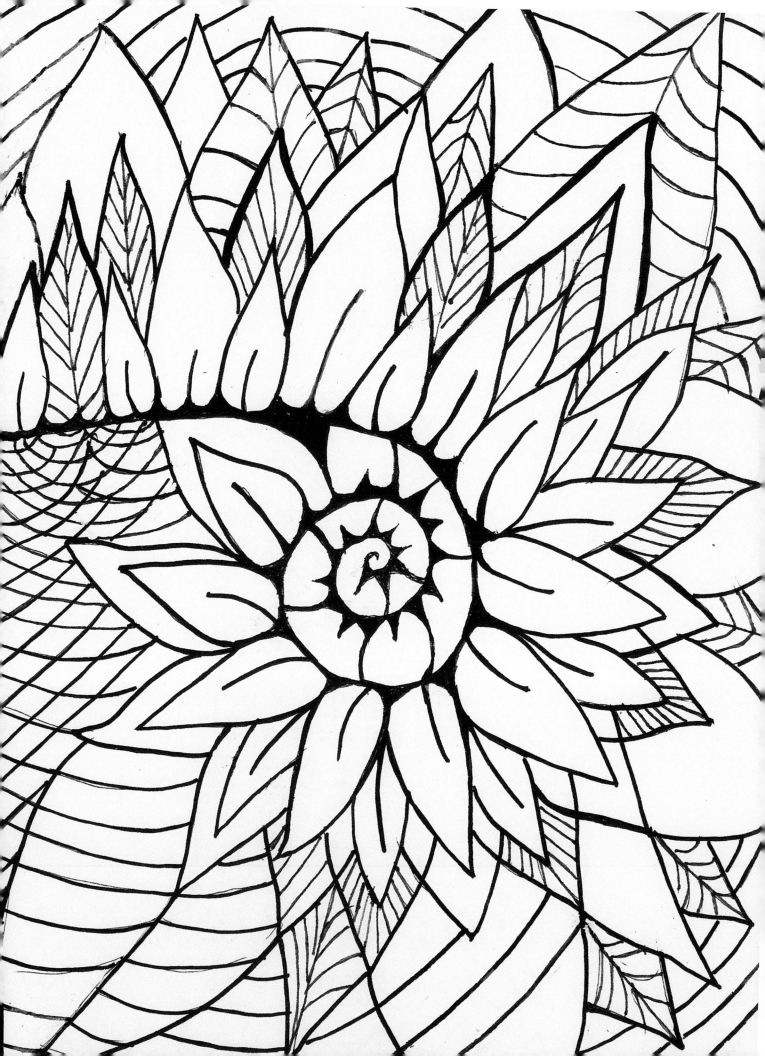

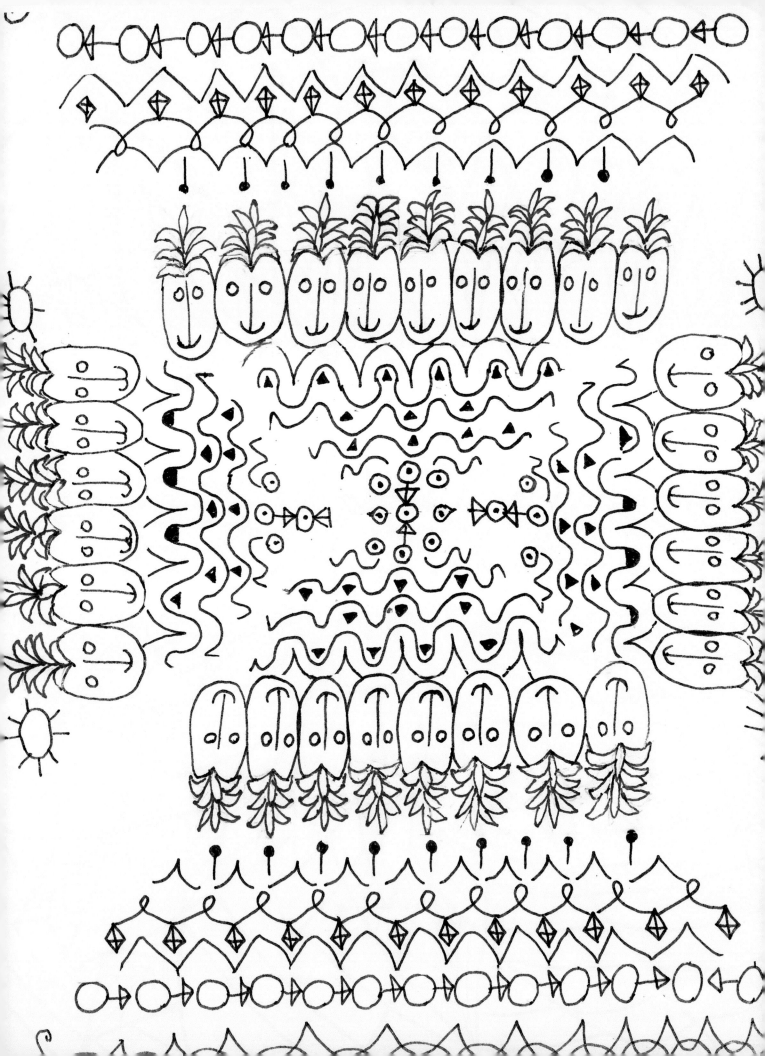

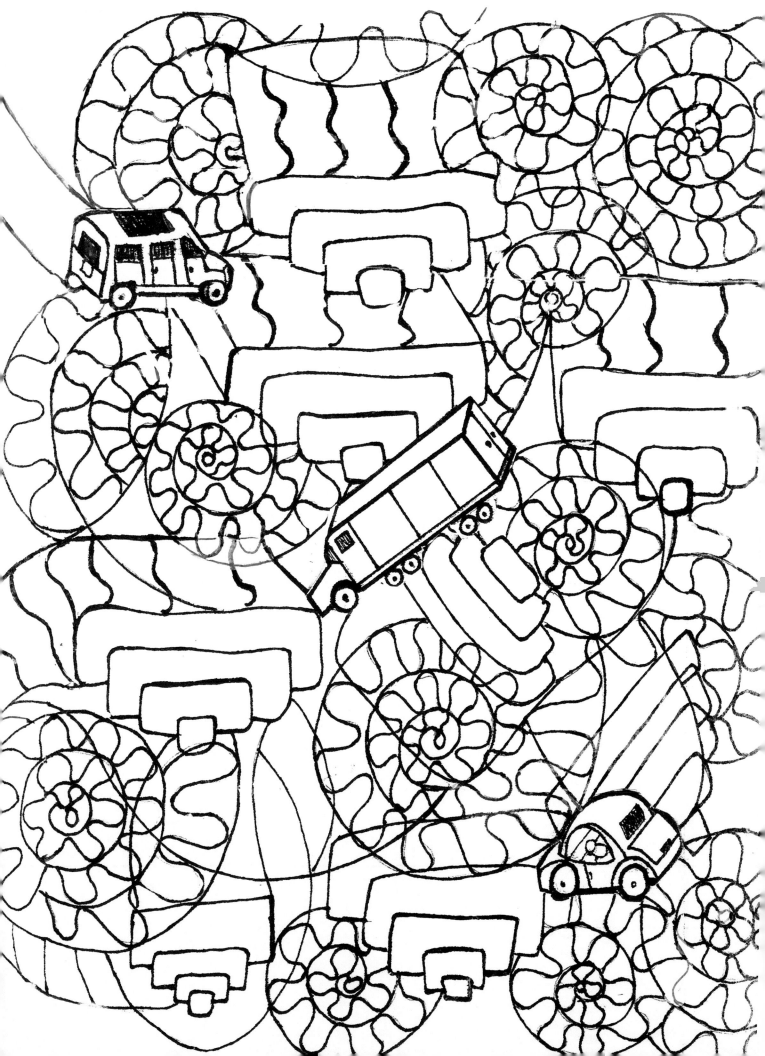

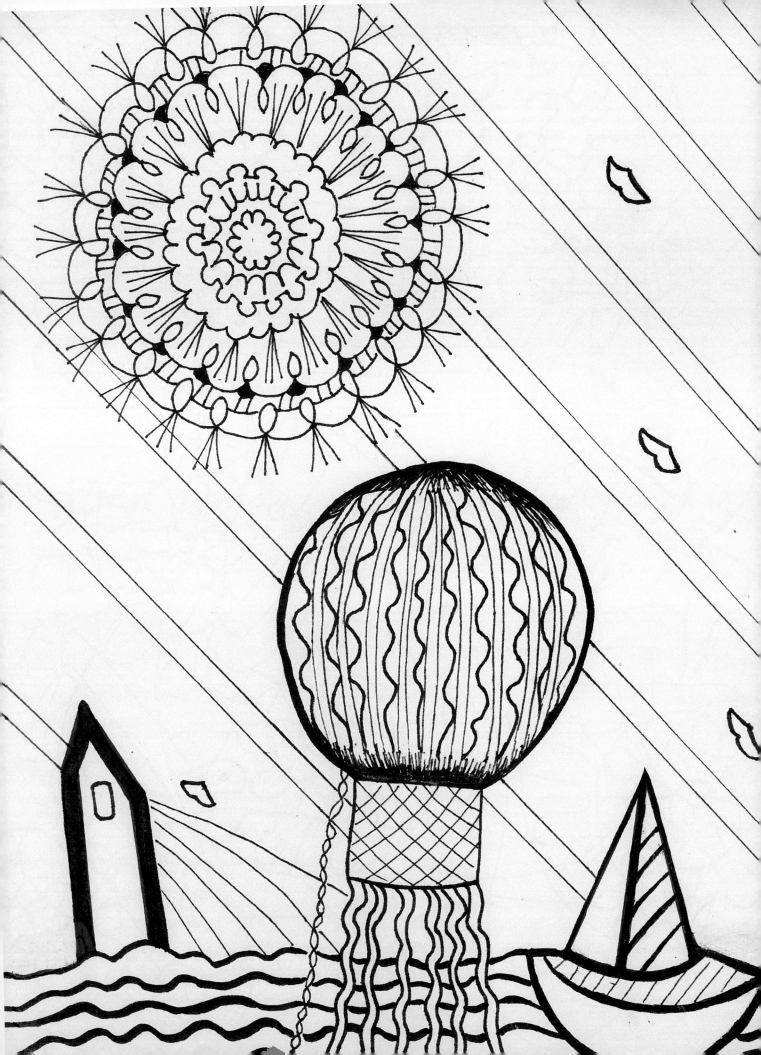

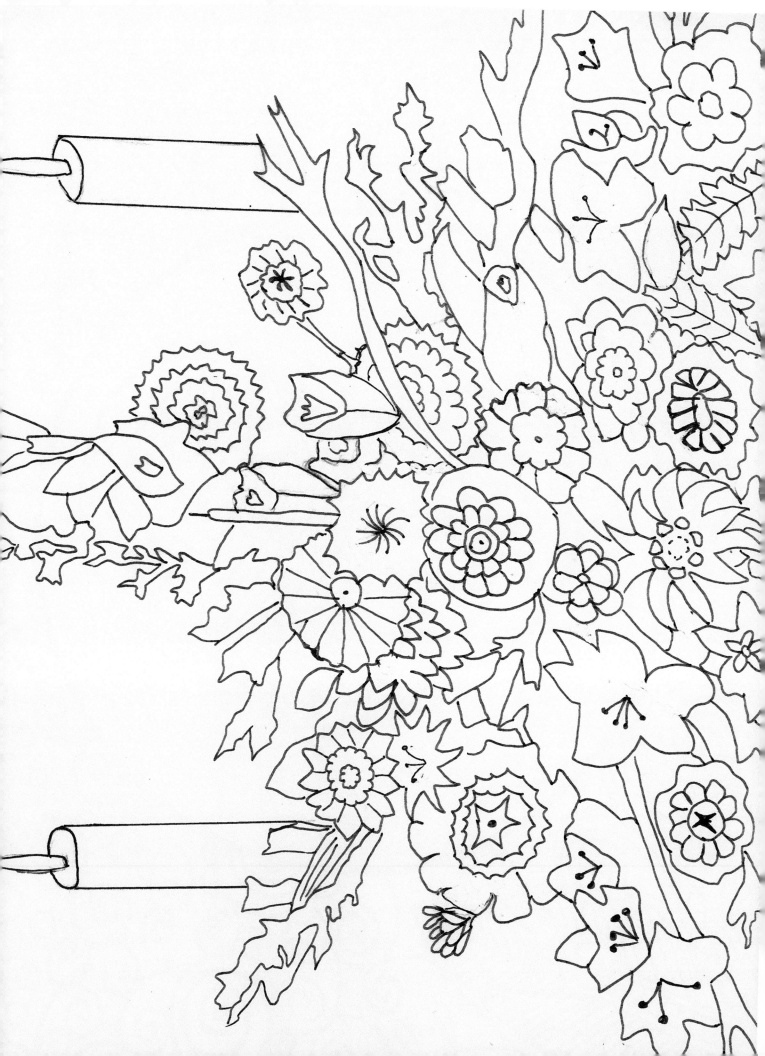

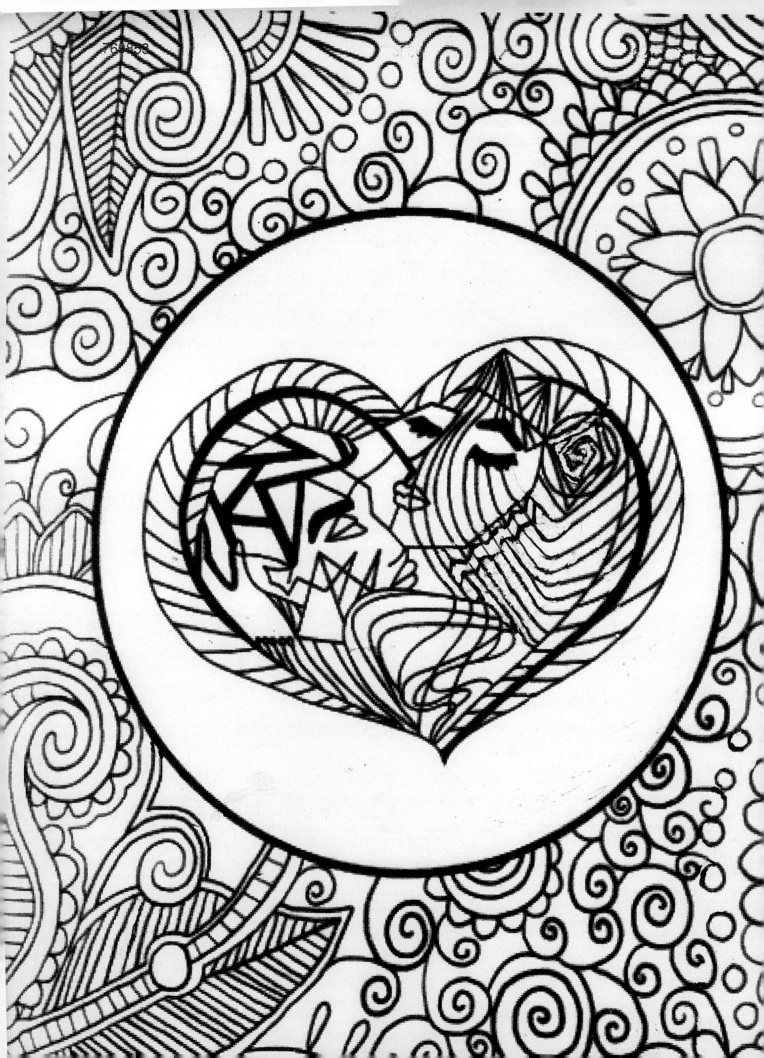

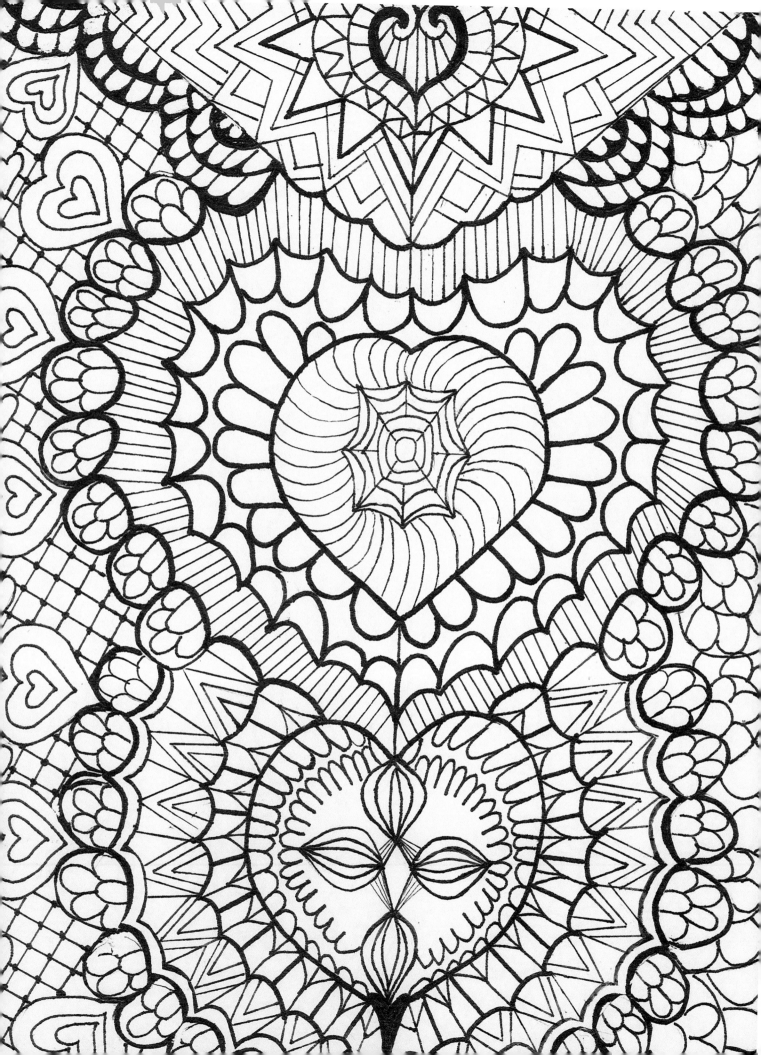

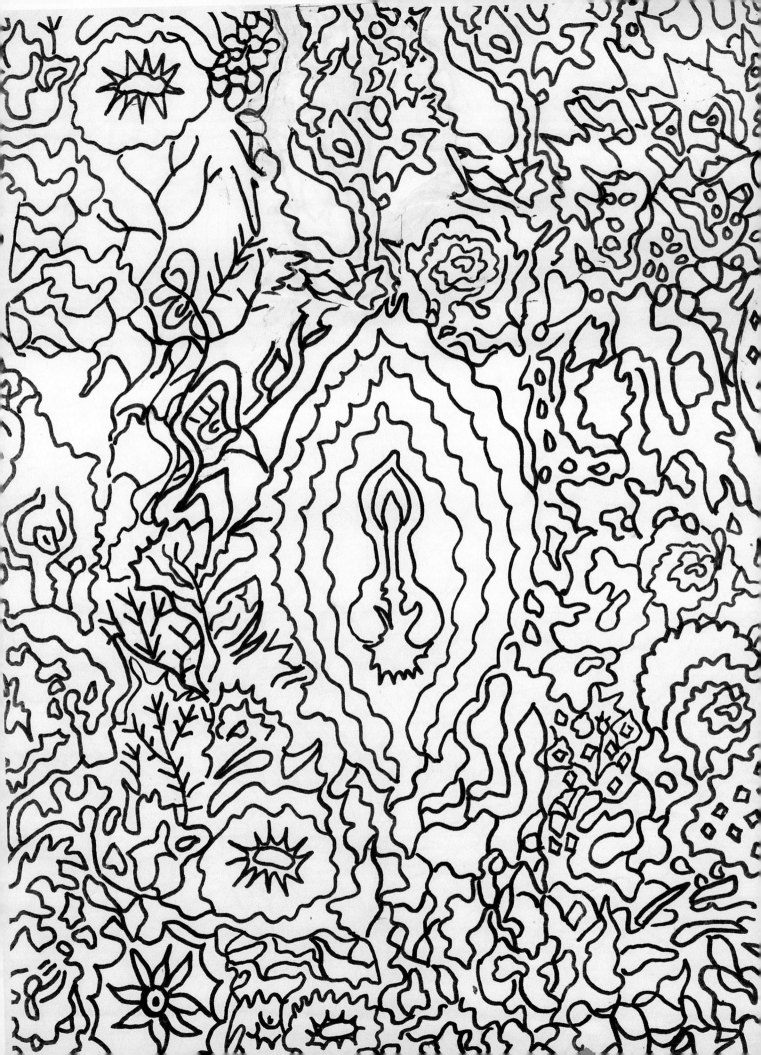

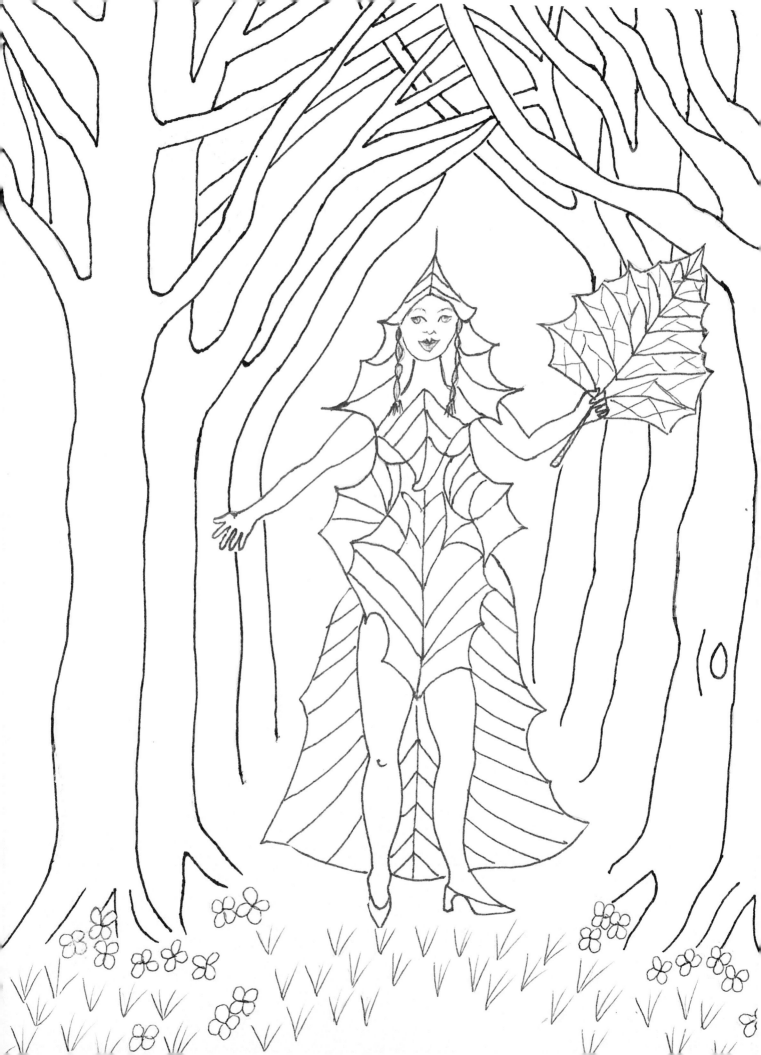

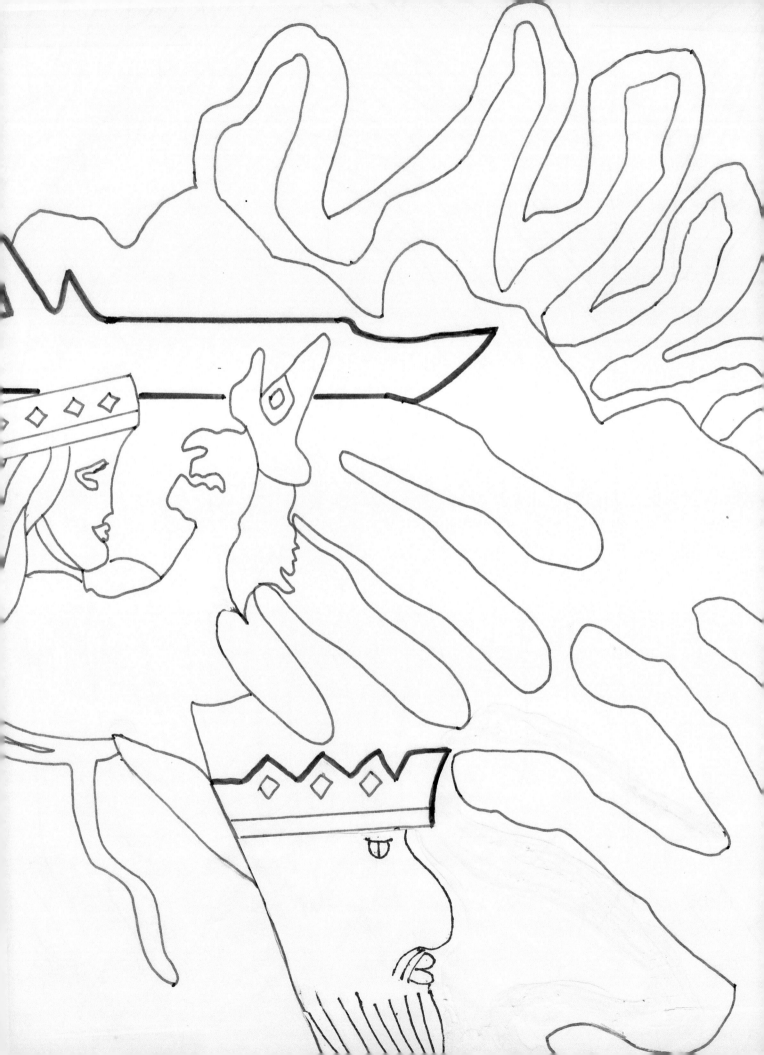

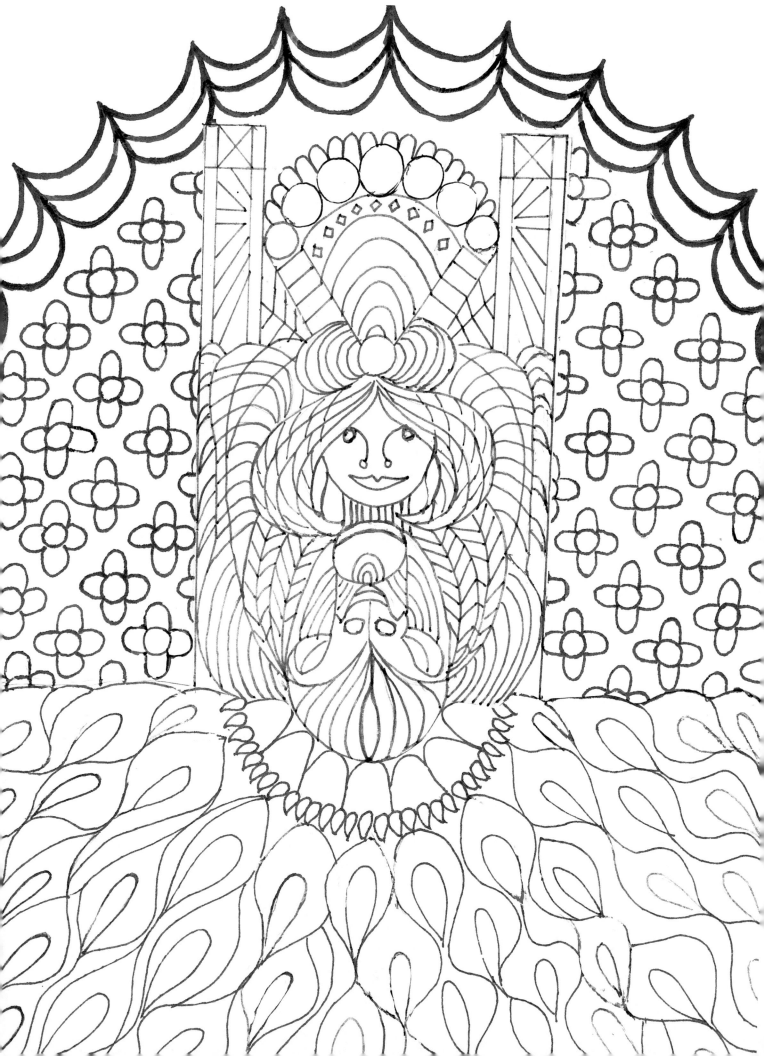

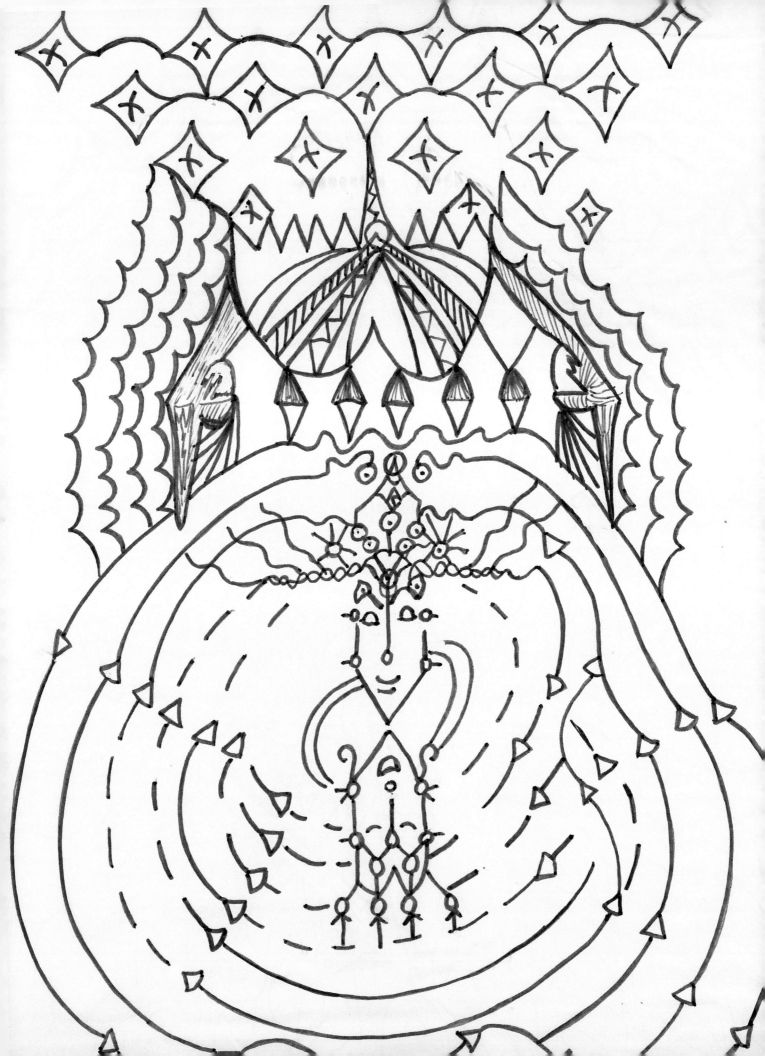

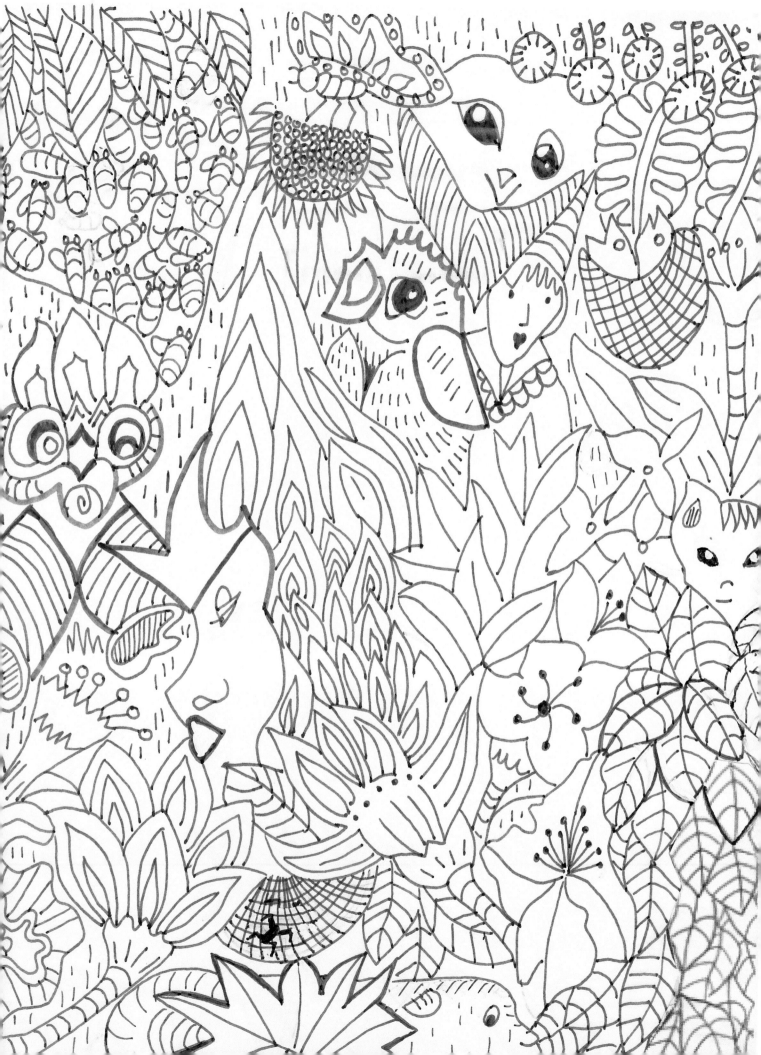

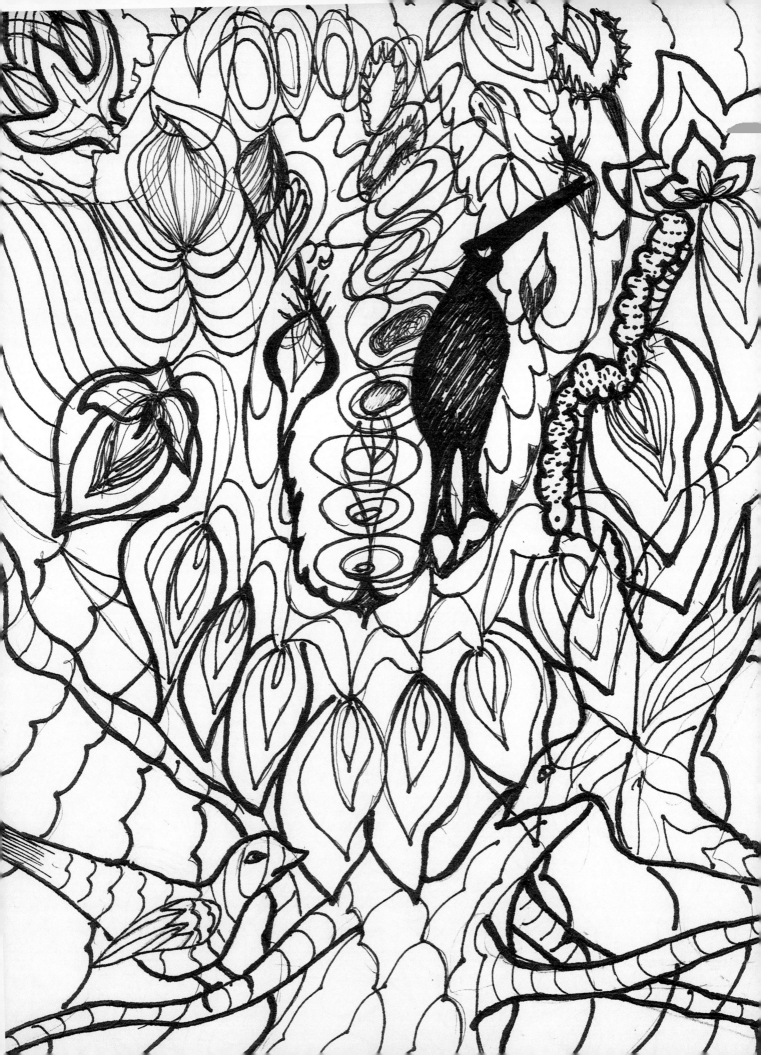

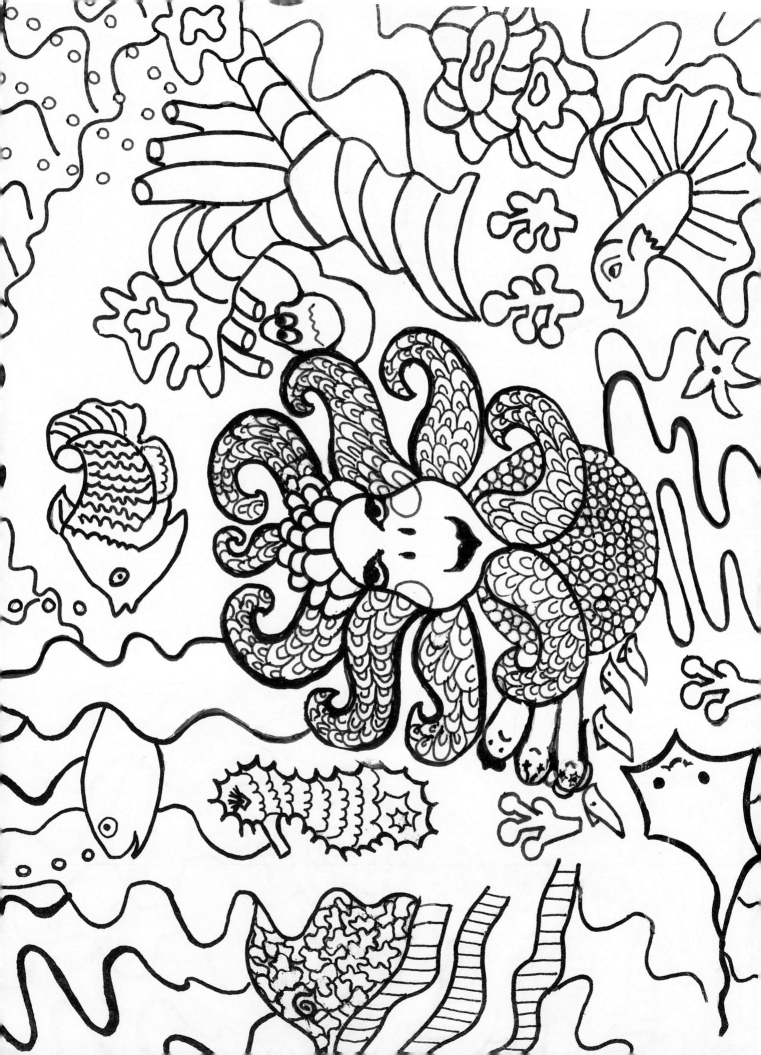

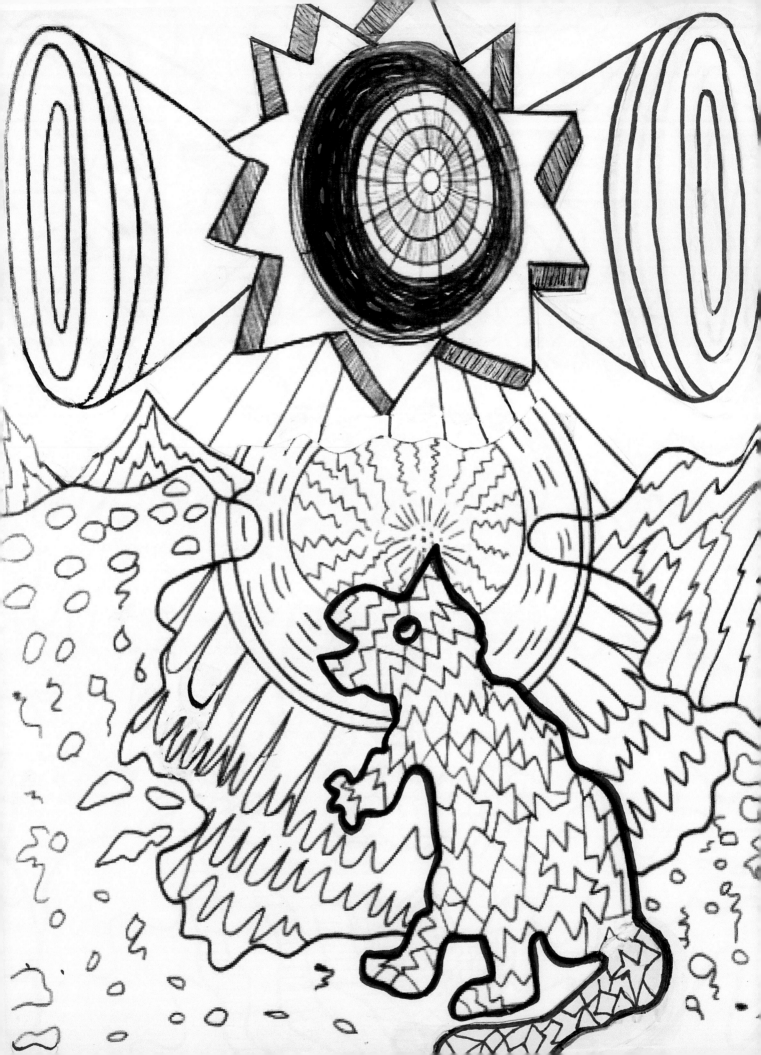

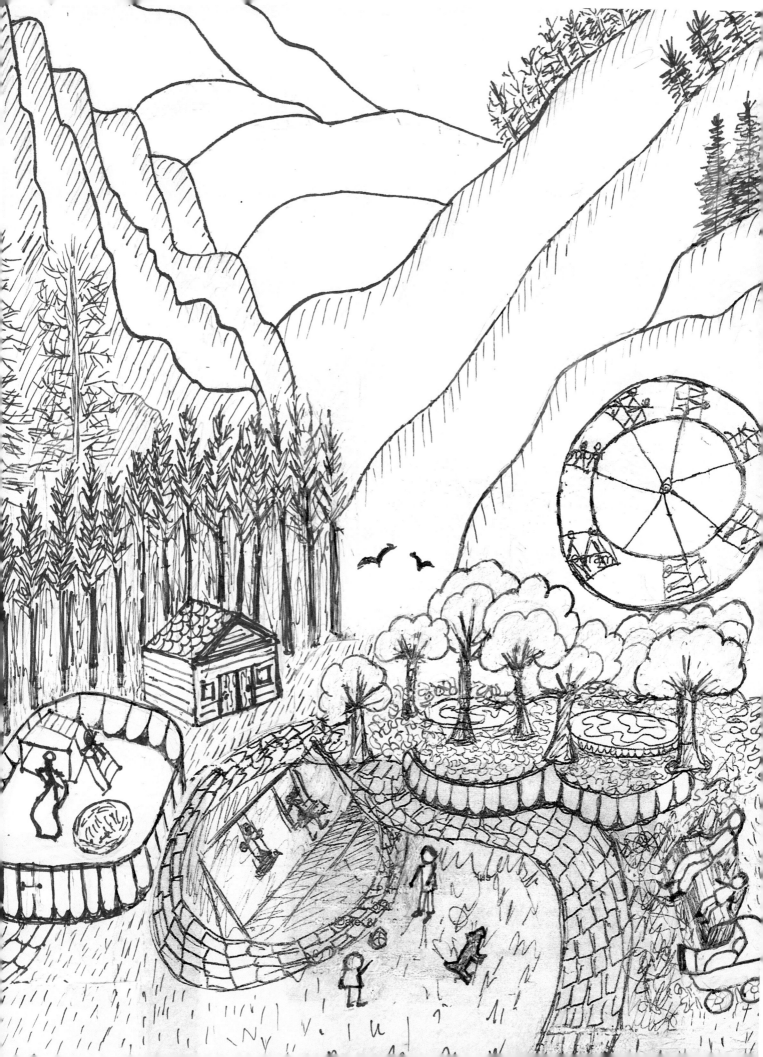

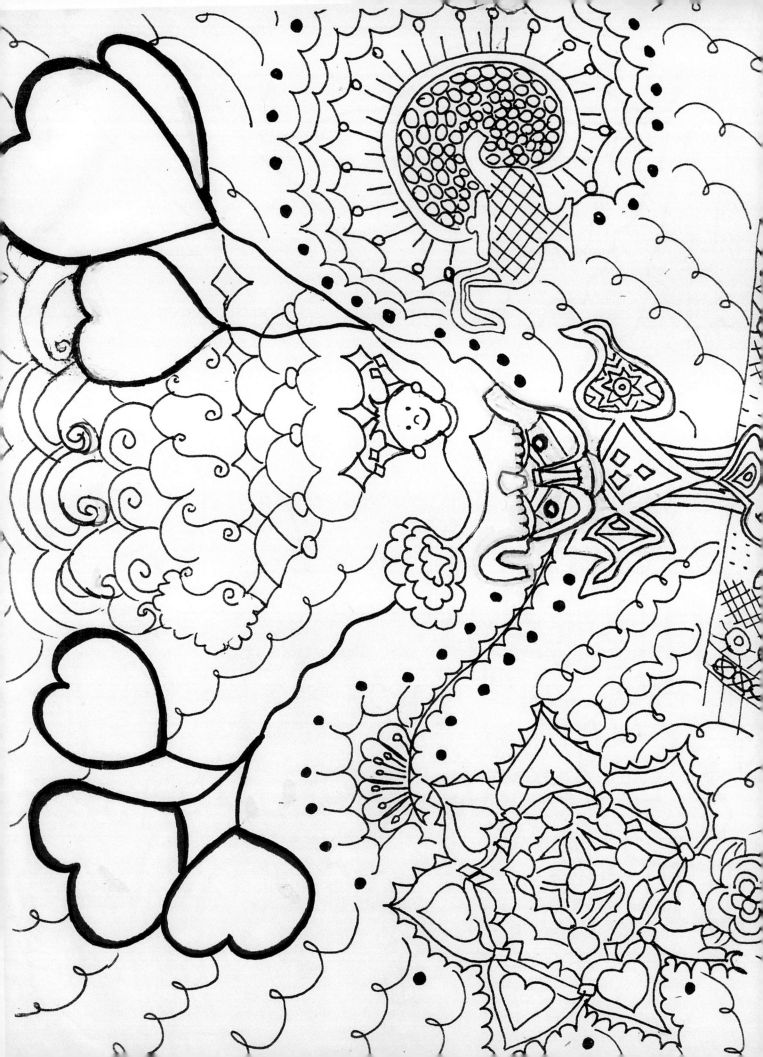

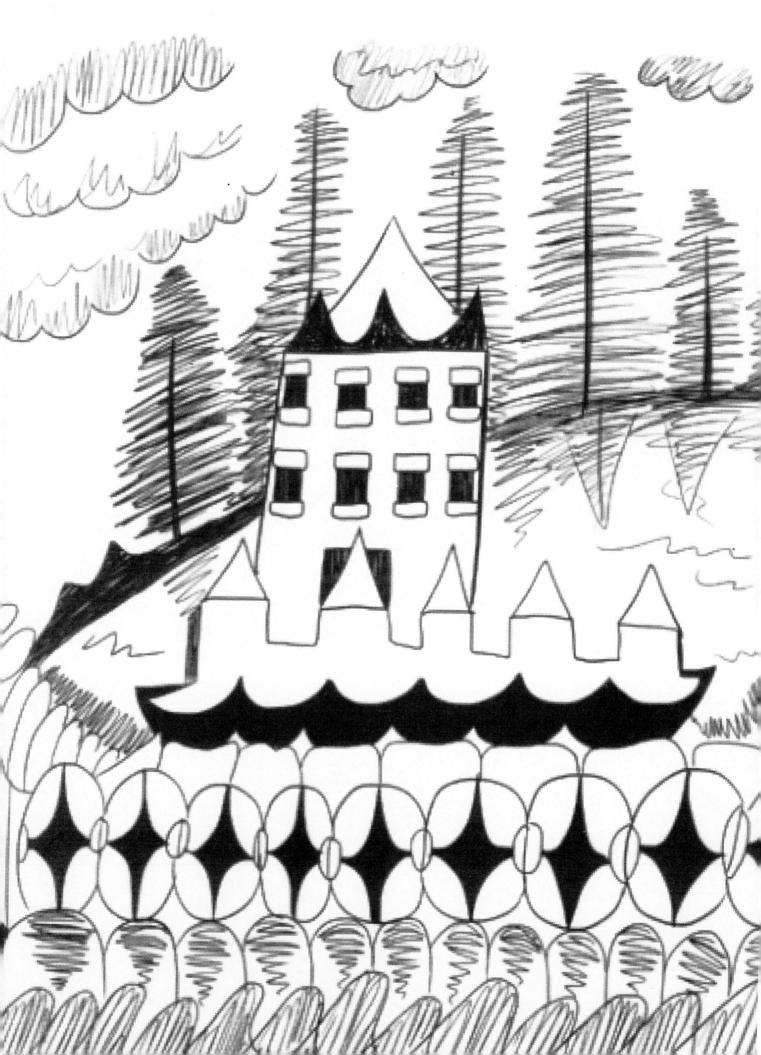

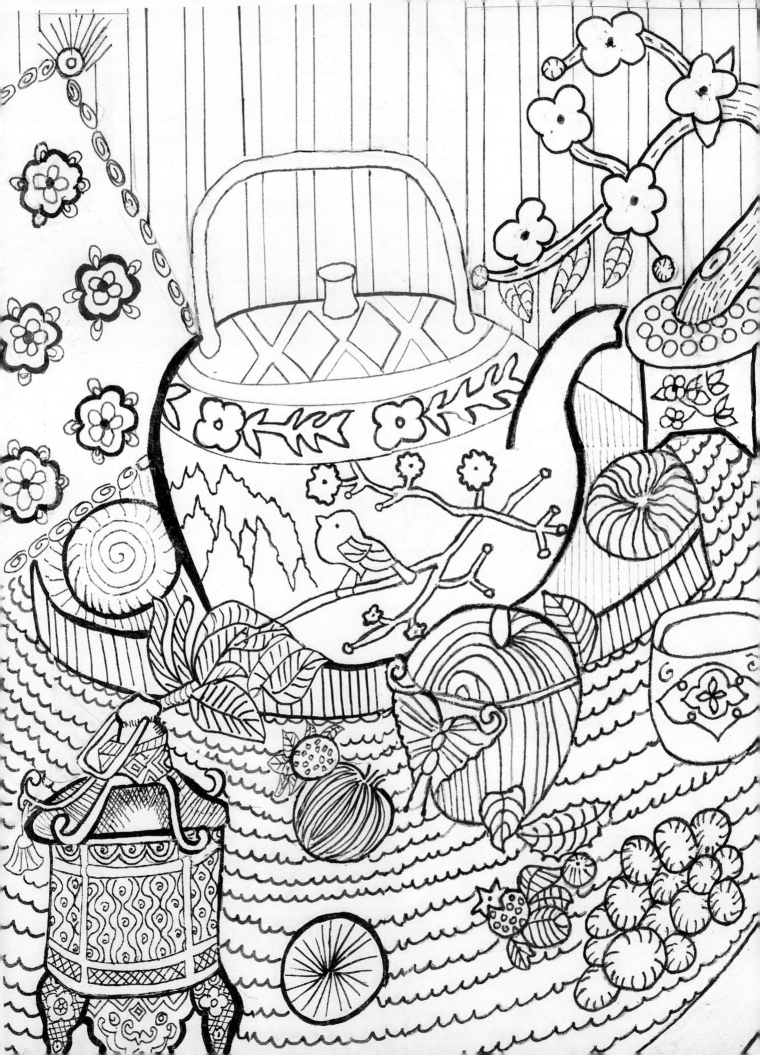

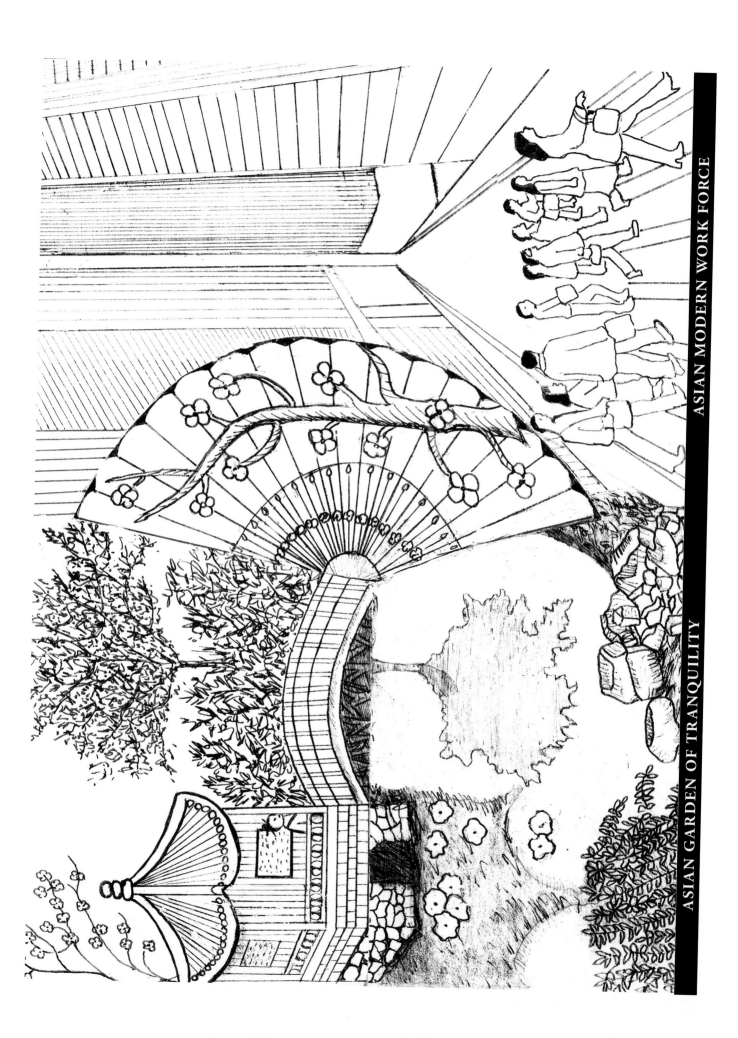

ASIAN GARDEN OF TRANQUILITY

ASIAN MODERN WORK FORCE

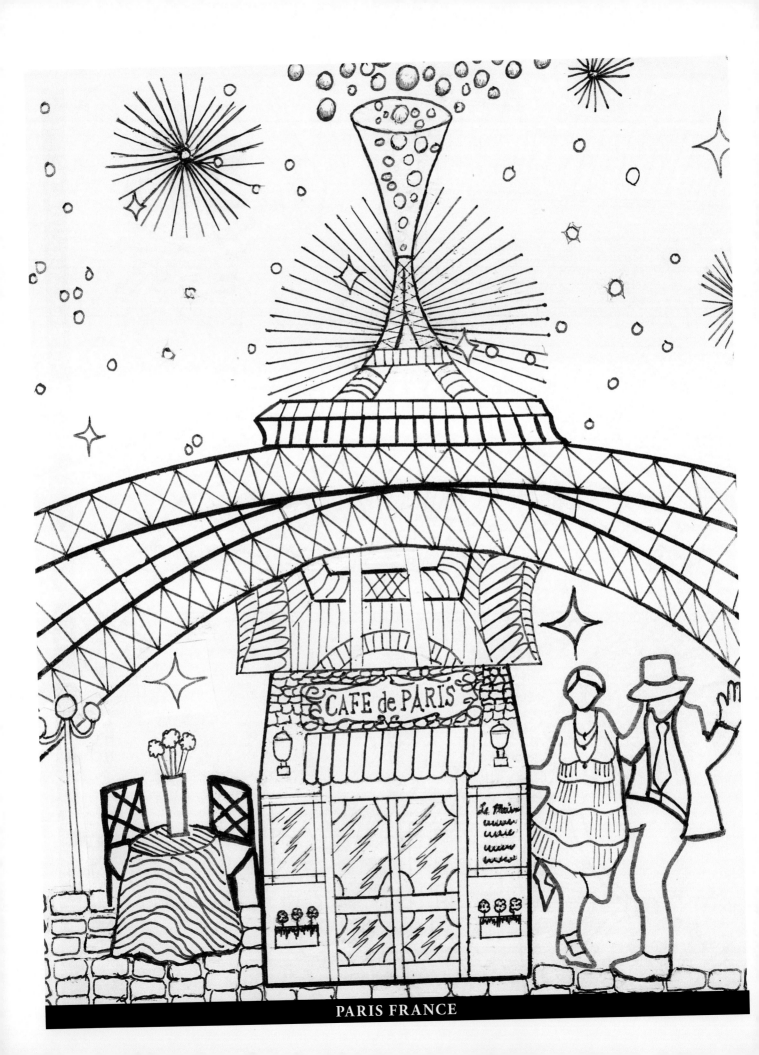

PARIS FRANCE

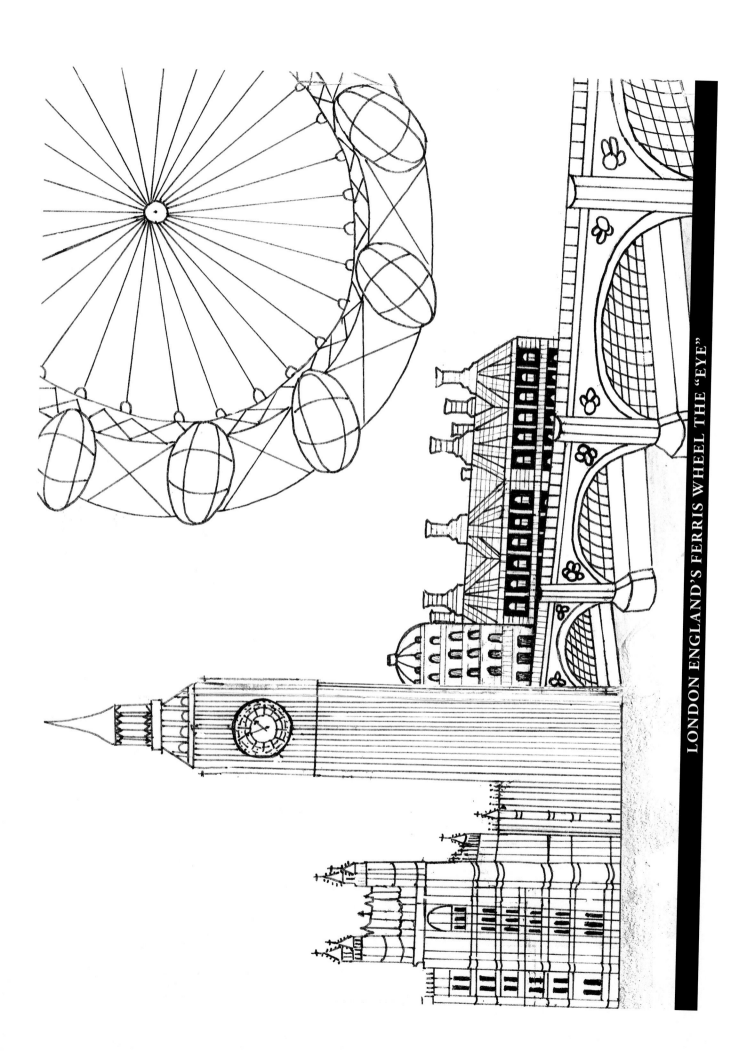

LONDON ENGLAND'S FERRIS WHEEL THE "EYE"

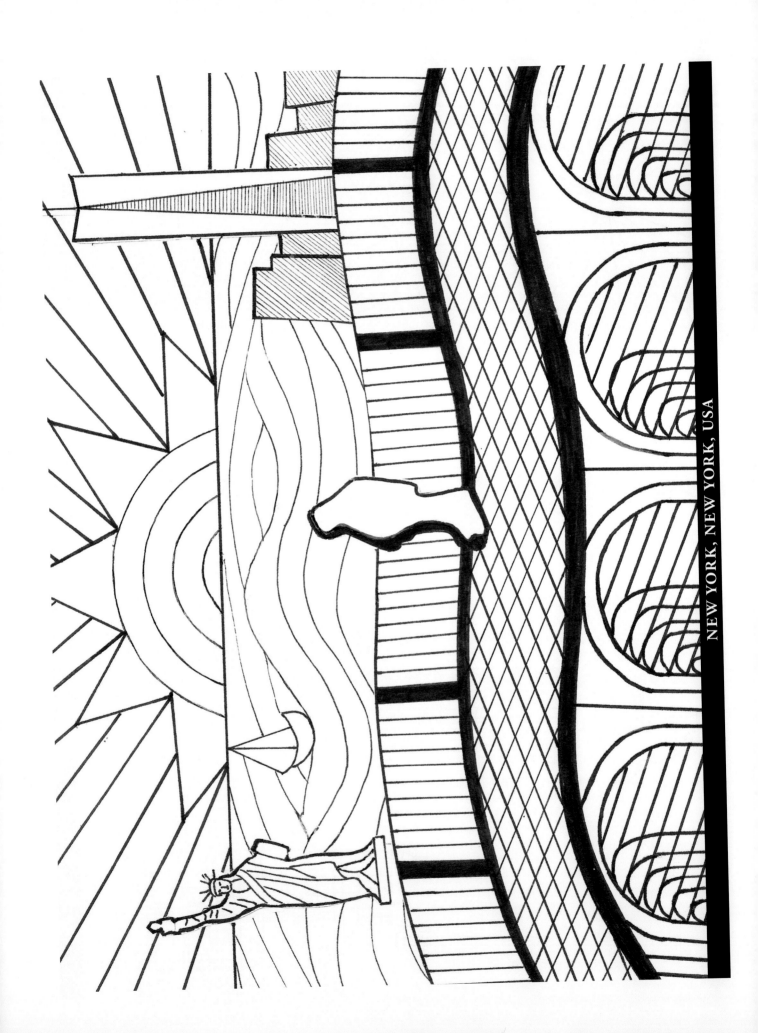

NEW YORK, NEW YORK, USA

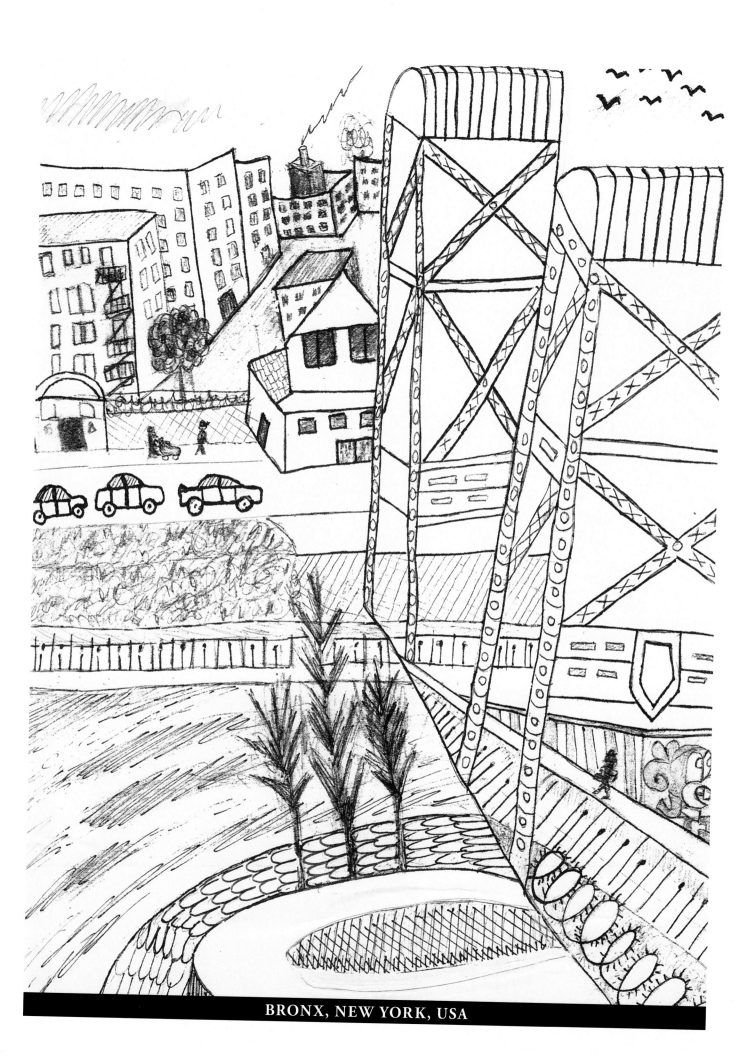

BRONX, NEW YORK, USA

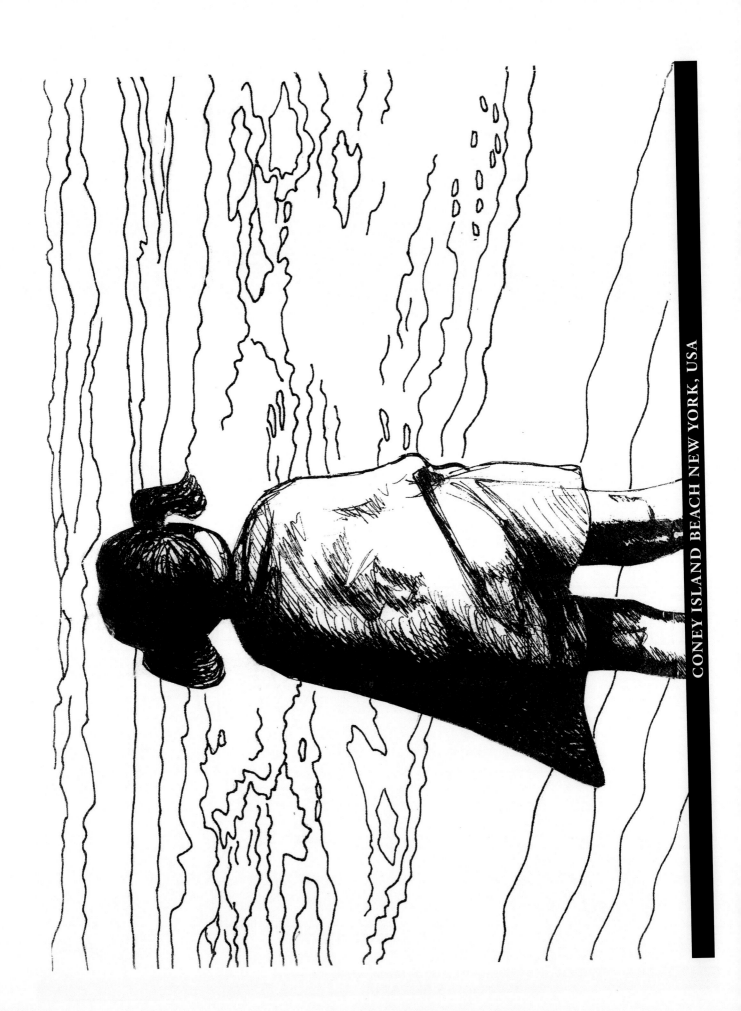

CONEY ISLAND BEACH NEW YORK, USA

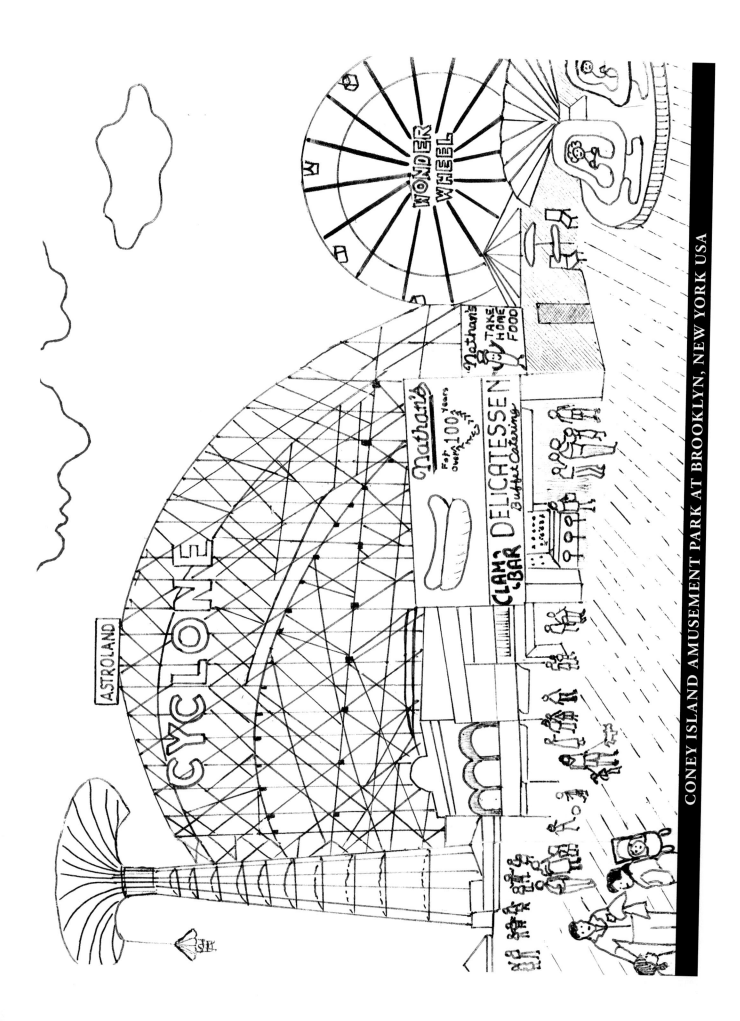

CONEY ISLAND AMUSEMENT PARK AT BROOKLYN, NEW YORK USA

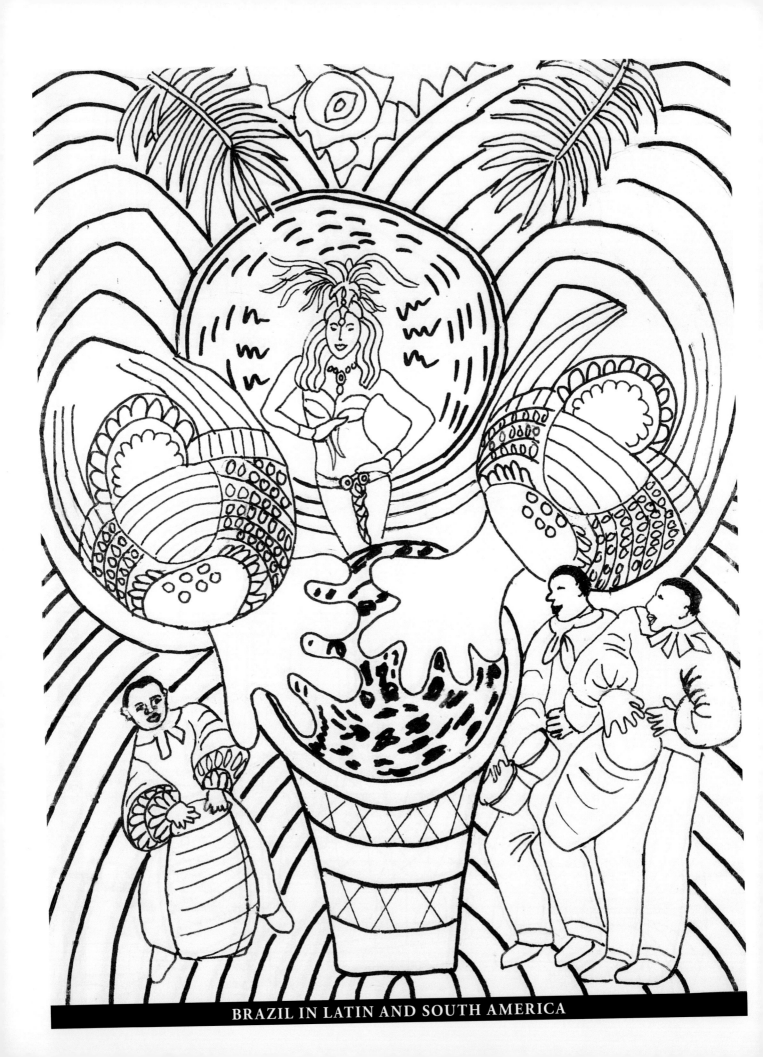

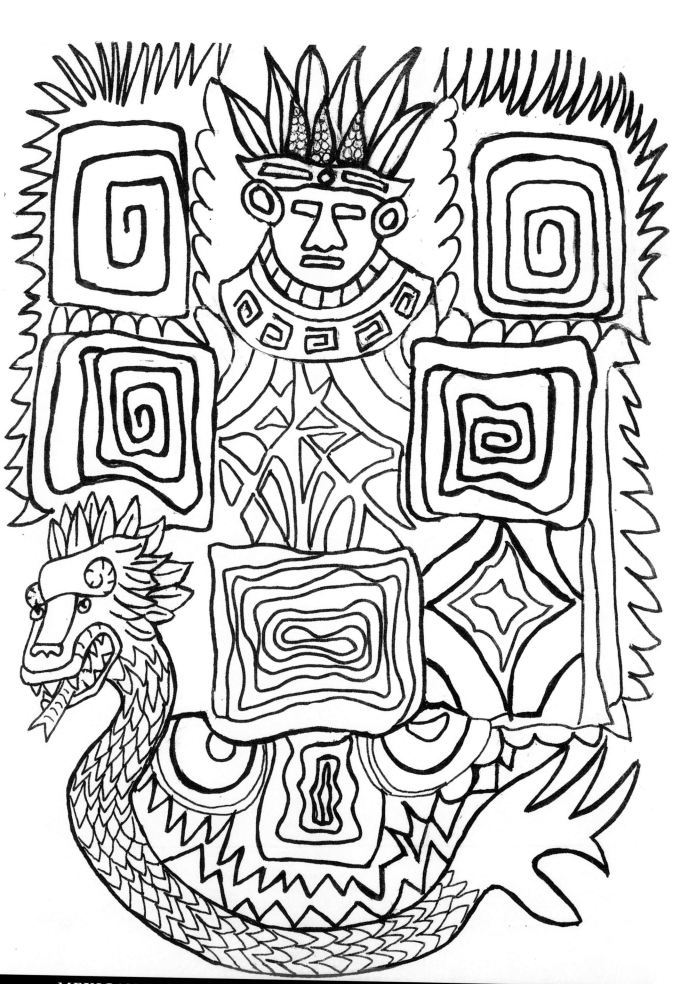

MEXICAN FEATHER HEADED DRAGEN DIETY "QUETZALCOATL"

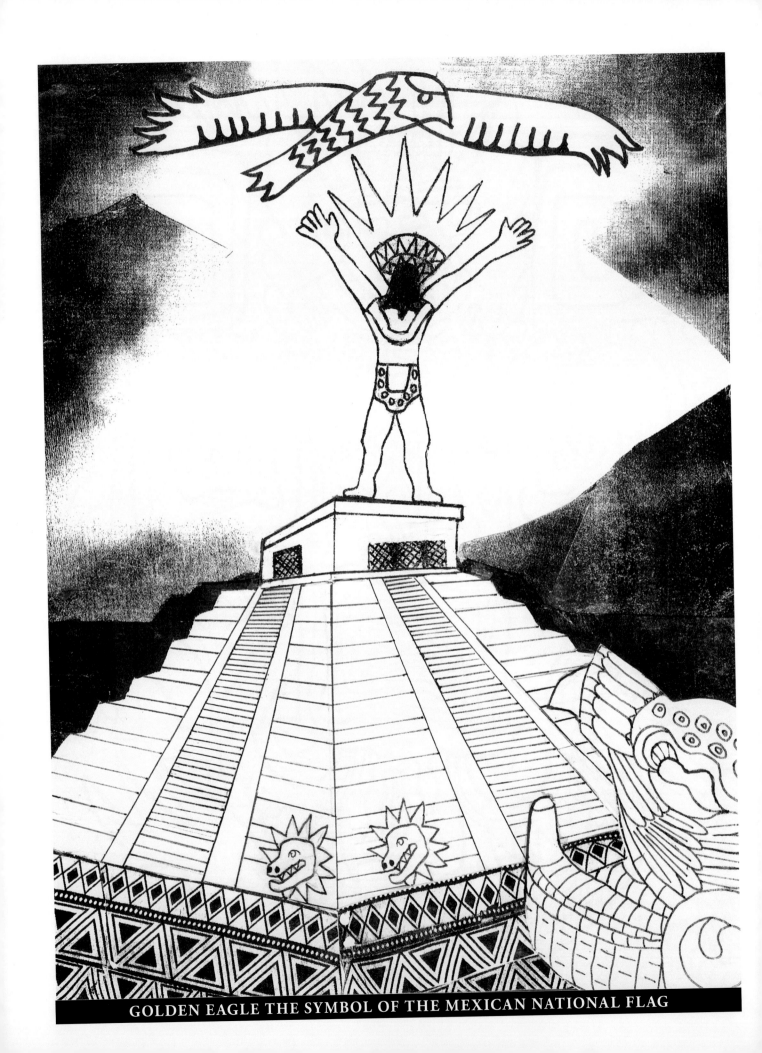

GOLDEN EAGLE THE SYMBOL OF THE MEXICAN NATIONAL FLAG

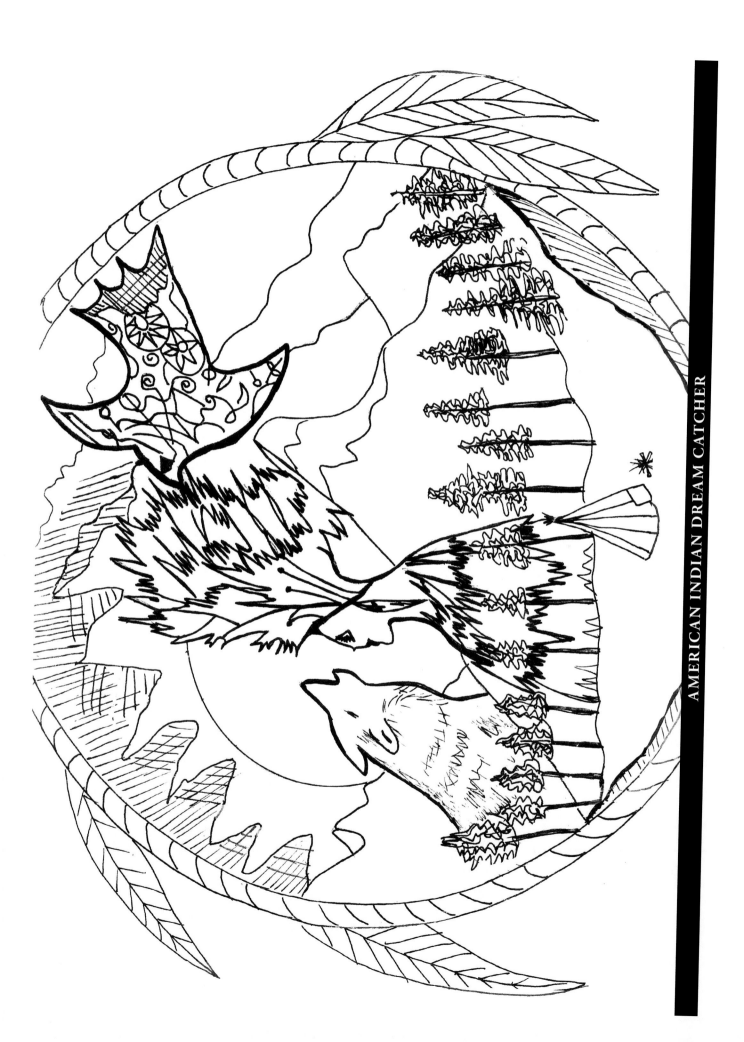

AMERICAN INDIAN DREAM CATCHER

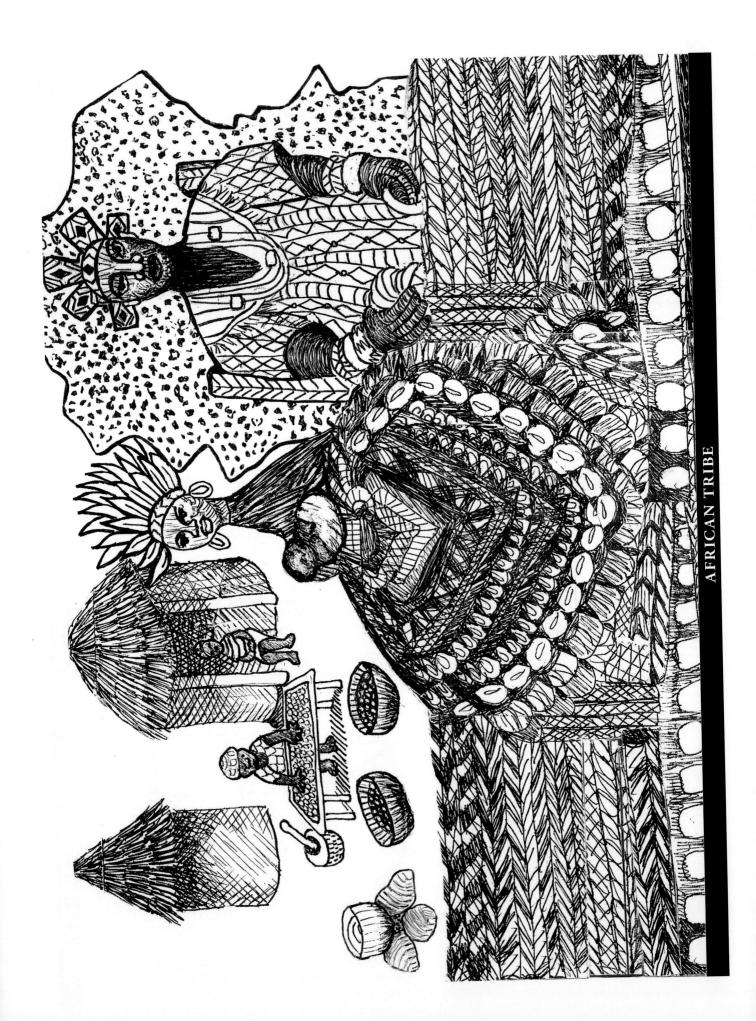

AFRICAN TRIBE

COLOR MIXING

Primary Colors

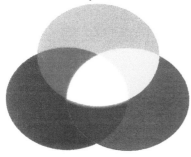

Secondary Colors

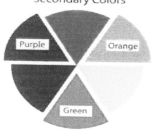

Tertiary Colors

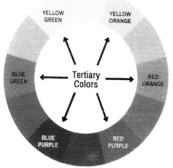

Primary Colors are:
Red
Blue
Yellow

Complomentary Colors:
Red - Green
Orange - Blue
Yellow - Purple

Secondary Colors are made up of
Primary Colors mixed together:
Red + Blue = Purple
Blue + Yellow = Green
Yellow + Red = Orange

Warm Colors:
Red
Red - Orange
Yellow
Yellow – Orange

Cool Colors:
Violet
Blue - Violet
Green
Blue - Green

Tertiary

Yellow - Orange
Yellow – Green
Blue – Purple
Blue – Green
Red – Orange
Red - Purple

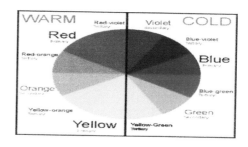

**All color combinations are good, you can choose
whatever color you like and enjoy!**